Monet: Late Paintings of Giverny from the Musée Marmottan

Monet

LATE PAINTINGS OF GIVERNY FROM THE MUSÉE MARMOTTAN

essays by

Lynn Federle Orr
Paul Hayes Tucker
Elizabeth Murray

published by

NEW ORLEANS MUSEUM OF ART
and
THE FINE ARTS MUSEUMS OF SAN FRANCISCO

This catalogue was published in conjunction with the exhibition *Monet: Late Paintings of Giverny from the Musée Marmottan*.

New Orleans Museum of Art
7 January–12 March 1995

The Fine Arts Museums of San Francisco
M. H. de Young Memorial Museum
25 March–29 May 1995

Reissued with a new Foreword in 1998 for the following exhibition venues:

The Walters Art Gallery, Baltimore
29 March–31 May, 1998

San Diego Museum of Art
27 June–30 August 1998

Portland Art Museum, Oregon
20 September 1998–1 January 1999

Monet: Late Paintings of Giverny from the Musée Marmottan was originally organized by the New Orleans Museum of Art and The Fine Arts Museums of San Francisco. The paintings are generously lent by the Musée Marmottan, Paris.

© 1994 by The Fine Arts Museums of San Francisco

All photographs of objects in the exhibition reproduced courtesy of the Musée Marmottan, Paris.

First published in 1994 by the New Orleans Museum of Art and The Fine Arts Museums of San Francisco and distributed by Harry N. Abrams, Incorporated, New York. A Times Mirror Company

Library of Congress Cataloging-in-Publication Data

Orr, Lynn Federle, 1947–
 Monet : late paintings of Giverny from the Musée Marmottan / essays by Lynn Federle Orr, Paul Hayes Tucker, Elizabeth Murray.
 p. cm.
 Catalog of an exhibition held at the New Orleans Museum of Art, Jan. 7–Mar. 12, 1995, and at the M.H. de Young Memorial Museum, San Francisco, Mar. 25– May 29, 1995.
 Includes bibliographical references (p.).
 ISBN 0-8109-2610-5 (pbk.)
 1. Monet, Claude, 1840–1926—Exhibitions.
2. Giverny (France) in art—Exhibitions. 3. Monet, Claude, 1840–1926—Homes and haunts—France—Giverny—Exhibitions. 4. Monet, Claude, 1840–1926—Contributions in horticulture—Exhibitions. I. Monet, Claude, 1840–1926. II. Tucker, Paul Hayes, 1950– . III. Murray, Elizabeth, 1953– . IV. Musée Marmottan. V. New Orleans Museum of Art. VI. M.H. de Young Memorial Museum. VII. Title.
ND553.M7A4 1994
759.4--dc20 94-37606
 CIP

ISBN 0-8109-2610-5

FRONT COVER: *The Pond of Water Lilies*, 1917–1919, cat. no. 8 (detail)

BACK COVER: *Monet in His Giverny Garden*, ca. 1923. Autochrome. © SYGMA

Printed and bound in Great Britain

Contents

Sponsors

PORTLAND ART MUSEUM

Grand Patrons
Janet and Richard Geary

Additional Support
Nordstrom, KeyBank, U.S. Trust—Charles and Caroline Swindells

Foreword

This exhibition brings into focus a less familiar aspect of a most familiar artist: the late paintings of Claude Monet. His works of the first decades of the twentieth century, some of the most personal and profound of his long career, are now being examined in depth by art historians interested in, among other things, the interrelationship between impressionism and abstraction. The twenty-two paintings in this exhibition will introduce hundreds of thousands of American museum-goers to the rich and startling body of work Monet created in the final years of his life, surrounded by the glorious gardens at this home in Giverny, which he considered one of his greatest masterpieces. These paintings represent the culmination of his lifelong preoccupation with light, color, and atmosphere.

The exhibition would not be possible without the cooperation of the staff of the Musée Marmottan, Paris, whose holdings of works by Monet are unequaled anywhere in the world. We acknowledge especially Monsieur Arnaud d'Hauterives, member of the Institut de France, who directs the Musée Marmottan, for his assistance and generosity in sharing these paintings with the American public.

The Walters Art Gallery, San Diego Museum of Art, and Portland Art Museum, as well as the Musée Marmottan, wish to acknowledge Monsieur Bernard R. Braem, Cultural Attaché, Embassy of France, for his interest in and support of our mutual undertaking. We thank the staffs of our three American museums for their collaboration in presenting the exhibition.

Special recognition is due our colleagues at the New Orleans Museum of Art and the Fine Arts Museums of San Francisco. In 1995 those two institutions presented the first American exhibition of these paintings. Their generous sharing of information, research, and material preparation, including the original and reissued editions of this catalogue, has been of enormous assistance to us in developing this American tour.

Gary Vikan
DIRECTOR, THE WALTERS ART GALLERY

Steven Brezzo
DIRECTOR, SAN DIEGO MUSEUM OF ART

John E. Buchanan, Jr.
EXECUTIVE DIRECTOR, PORTLAND ART MUSEUM

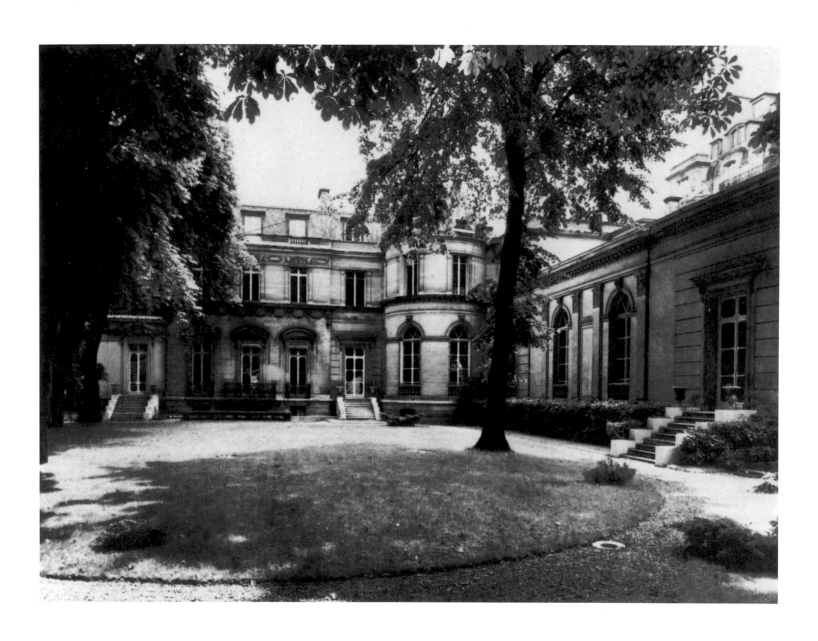

The Musée Marmottan and Claude Monet

T oday the Musée Marmottan owns the world's most important collection of works by Claude Monet—eighty-seven oil paintings as well as pastels, caricatures done in his youth, and sketchbooks that contain numerous studies for his paintings. However, no one could have foreseen that this historic private residence would one day become the center for the appreciation of impressionism. Bought in 1882 by Jules Marmottan from the duke of Valmy, the house was converted by his son Paul to showcase the family's Napoleonic collections. The building and collections were bequeathed to the Institut de France in 1932, and it was opened to the public as a museum two years later. It was only in 1957 that Madame Donop de Monchy, daughter of Doctor de Bellio (friend and physician to many artists), donated to the Musée Marmottan her father's collection with its six Monets, among them the celebrated *Impression: Sunrise* (Orr, fig. 6).

This gift probably prompted Michel Monet, the youngest son of the painter, to bequeath to the Académie des Beaux-Arts the property at Giverny and those of his father's works that remained in his possession. After Michel's death in an automobile accident in 1966, the paintings came to the Marmottan, and a specially constructed wing for the Monet collection opened in 1971. Today this donation forms the core of the Musée Marmottan's outstanding collection of works by Claude Monet. The majority of these canvases date from the last part of Monet's life and were inspired by his property at Giverny.

Monet first fell in love with this charming residence, which he discovered while out walking, in 1883. He lived there until his death, in 1926. Indefatigably, he arranged the house, added to it studios and greenhouses, and devoted much time to his constantly renewed garden. This desire to always improve the garden, to change the colors, is witness to the same fierce tenacity that led him to paint and repaint certain canvases in the search for an absolute that surpassed painting. Thus, in terms of his life, his garden was his most beautiful masterpiece, his unique source of inspiration, and, indeed, his final splendid palette of the changing colors of passing time.

OPPOSITE: Musée Marmottan, Paris

Untiringly, Monet scrutinized his landscapes of water and reflections, the Japanese bridge, the rose arbor. Overturning the traditional classic conception of landscape, Monet represented only a fragment of his subject, enlarged, transposed. He exalted color, allowing a whirl of animated brushstrokes to overpower the subject.

In 1980 Daniel Wildenstein decided to give to the museum the extraordinary collection of late medieval illuminated manuscripts assembled by his father, Georges Wildenstein. This gift comprised 228 French, Italian, German, English, and Flemish works. The different holdings of the Musée Marmottan were magnificently rounded out in 1987 with the Donation Henri Duhem. Originally from Douai, Henri Duhem very early on abandoned his career as a lawyer to devote himself exclusively to painting. Friends with the post-impressionists, he, like Gustave Caillebotte, was a passionate collector. He acquired works by his friends and by their immediate predecessors. He succeeded in forming a very representative ensemble of paintings, pastels, and sculptures by Boudin, Carrière, Corot, Guillaumin, Monet, Pissarro, Renoir, Rodin, Lebourg, and Le Sidaner.

In recent years, thanks to several very generous patrons such as Reader's Digest, the NTV, and the Club Pommery, the museum has undergone numerous improvements: renovation of the second floor and the Monet Room (with state-of-the-art lighting by Philipps), as well as the creation of a new bookstore. This last offers a complete survey of everything that has been published on the work of Claude Monet (scholarly books, exhibition catalogues, posters, postcards, etc.) and many luxury articles.

For several years the museum has conducted a policy of sharing the rich resources of our collection through the organization of several national and international exchanges. Since 1975 we have organized two exhibitions a year on average dedicated either to an individual artist or to a private collection, among them Toulouse-Lautrec (1976), Boilly (1984), Daumier (1989), Goya (1990), Boldini (1991), and the collections of Reader's Digest (1986) and Bentinck Thyssen (1986). At the same time, private foundations and foreign museums are increasingly eager to show works from the Marmottan. Thus, the Juan March Foundation in Madrid presented a portion of the Monets from the Marmottan's collection. In 1992 a similar exhibition was shown at a succession of institutions, including the Palazzo dei Diamanti, Ferrara; National Palace Museum, Taipei (Taiwan); and at the Louisiana Museum, Humlebaek, Denmark.

We responded with great pleasure when the New Orleans Museum of Art and The Fine Arts Museums of San Francisco asked to exhibit these works in 1995. The interest in the paintings is such that they will again travel—in 1998 to the Walters Art Gallery, the San Diego Museum of Art, and the Portland Art Museum, and in 1999 to the Musée des Beaux-Arts de Montréal, the Albright-Knox Art Gallery, and the Phoenix Art Museum. Our hope that the exhibition would provide bonds of friendship among countries seems to be well realized.

Arnaud d'Hauterives
MEMBER OF THE INSTITUT DE FRANCE
CURATOR OF THE MUSÉE MARMOTTAN

Monet: An Introduction

Lynn Federle Orr

he classic impressionist paintings of Claude Monet's early period,
featuring sun-drenched views of the French countryside and bustling
scenes of urban Paris, are today greatly loved by American museum
goers. However, after 1900 Monet's artistic concerns shifted to a sub-
ject of his own creation: the gardens on his property in Giverny. He focused on these
gardens almost exclusively for over twenty years. In the late paintings, the aging Monet,
hampered by physical limitations and deteriorating eyesight, moved beyond conven-
tional modes of representation. Broad, energetic brushstrokes of vibrant color float on
the two-dimensional surface of the canvas in the same manner that his organic subjects
appear without stabilizing reference to ground plane or horizon line. Celebrating color
and form at the expense of objective reality, these late works by the master are generally
less known to American audiences. Against the background of Monet's earlier impres-
sionist style, many viewers will find the daring handling in these paintings surprising
and their anticipation of later aspects of modernism, such as abstract expressionism,
remarkable. However, scholars now recognize the full genius of the Giverny paintings,
which bridge the disparate artistic vocabularies of the nineteenth and twentieth centuries.

The general acceptance and critical acclaim accorded Monet today eluded the artist
until the last decade of the nineteenth century, by which time he had already been part
of the Paris art scene for nearly thirty years. Monet's choice of subjects, painterly style,
and plein-air working methods (the very aspects of his art that we cherish) challenged
conventional practices and the authority of the French academy, which had been in place
for over two hundred years. It is worthwhile to understand these issues in the terms of
Monet's day; much was at stake for the conservative members of the art world, includ-
ing their own positions within the established hierarchy.

In his figural works Monet selected modern "histories" drawn from the everyday
lives of his contemporaries, disregarding the traditional repertoire of edifying subjects
based on mythological, religious, literary, or historical events of the past. Similarly, the
landscape motifs Monet chose were distinctly French and modern, punctuated by monu-
ments to society's technological progress, such as the railroad. Monet's artistic aims and

OPPOSITE: Detail from *Water Lilies*, cat. no. 1

working technique were equally suspect. Celebrating the transitory visual effects of light and color perceived in a fleeting glance, Monet's canvases were rendered *en plein air*, on the spot out-of-doors, in a broad, painterly manner. This method of rapidly laying down the paint succinctly captured the effect of "instantaneity" which Monet maintained was his aim.[1] Monet's critics, however, looked on his freely brushed paintings as incomplete, rehearsals for some later, polished artistic performance. Early critics of Monet, and of impressionism in general, uniformly attacked these departures from convention, as well as the artist's assertion that his quickly sketched personal impressions were valid works of art in their own right.

The impressionists, following the example of Barbizon and realist artists, who had championed both subjects drawn from contemporary life and the direct observation and recording of nature, stressed the realism of their images. But, unlike their academic contemporaries, the impressionists did not rely on line to render precisely the physical properties of the objects they depicted, such as contours and surface textures (these could now be replicated exactly by photography). Monet and his colleagues sought instead to capture the essence of a form as described by the light dancing across it. Created by a loose fusion of individual brushstrokes, the forms in impressionist paintings are abbreviated; only the most salient features of a face, drapery, or landscape motif are suggested. This very disinterest in detail, combined with the liberation of color and brushwork from their subservience to form, led the way to further abstraction. When Monet's famous oval mural of water lilies (Tucker, fig. 17) was unveiled at the Orangerie in Paris in 1927, it was noted:

> *It seems as if [Monet] were as interested in a leaf as in a dress, in a dress as much as in a face. Thus a sort of indifference to the relative value of objects begins to manifest itself, an indifference which, at the beginning, appeared to be the submission of a realist to every stimulus falling on his retina, and which, by an imperceptible and logical evolution, will become the whimsical power of the visionary who lends to things the appearance that he wishes. . . . His language differs more and more from nature, replaces it, and yet at the same time pretends to be more and more like it.*[2]

Looking across Monet's career, one perceives this gradual process of stylistic evolution.

Born in Paris on 14 November 1840, Monet grew up in Le Havre, where his family had moved in 1845. Monet's lifelong interest in light as a shimmering, moving subject may well have developed as a result of life in this seaport on the Normandy coast. He received his initial artistic instruction from a series of competent, if conventional, artists, first in Le Havre and then in Paris. However, an early acquaintance with the landscape painter Eugène Boudin was the determining influence in Monet's formative years. Boudin's paintings record the changing skies and seas along the Channel coast and portray elegant bourgeois ladies enjoying themselves on the resort beaches of Trouville. In both subject matter and his spontaneous brushwork, which focused only on essential features, Boudin can be seen as the precursor of Monet. Theoretically and formally, the two artists shared much in common, including a dedication to nature, experienced and painted directly out-of-doors. Contact with other realist artists, including Gustave Courbet, Charles-François Daubigny, and the Dutch landscape painter Johan Barthold Jongkind, reinforced Boudin's example, as can be seen in the broad technique and strong earth colors Monet used in early works executed along the coast of Normandy, such as

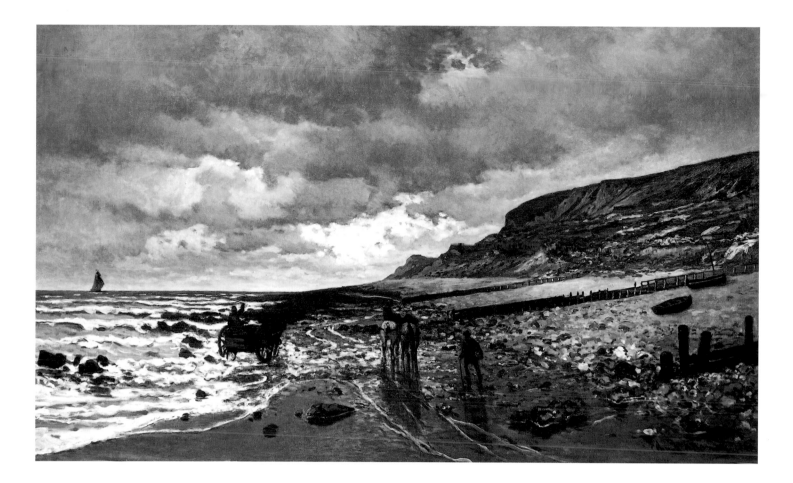

the *Pointe de la Hève at Low Tide* (fig. 1), and in the Forest of Fontainebleau.³ While returning frequently to paint in his childhood haunts, Monet had moved to Paris by the fall of 1862. There he joined fellow students Pierre-Auguste Renoir, Alfred Sisley, and Frédéric Bazille in the studio of the academician Charles Gleyre. Lasting friendships developed, bringing the artistic and personal camaraderie, and at times even financial assistance, that supported Monet through the early lean years of his career.

Monet first submitted works to the government-sponsored Salon in 1865. Two freely painted seascapes, both indebted stylistically to Boudin and Jongkind, were accepted for exhibition. During his early Paris period, Monet's works show the growing influence of Manet, as can be seen in his Salon entry of 1866, *Camille* (*The Green Dress*) (Kunsthalle, Bremen).⁴ Singled out in the press for his bravura display in the execution of the skirt of the dress, Monet was simultaneously ridiculed for his summary handling of the figure's face and hands.⁵

Monet's most important endeavor of 1865–1866 was the monumental *Luncheon on the Grass*, which was not ready in time for the Salon. Measuring close to twenty feet in width, the work represented twelve life-size figures gathered for a picnic in the shade of a grove of woodland trees. Obviously recalling Edouard Manet's famous *Luncheon on the Grass* (Musée d'Orsay, Paris), Monet's work is, however, without Manet's overt references to historical art. Monet's figures are not actors placed in some distant arcadia but rather are explicitly contemporary figures, rendered in heroic scale, enjoying themselves in the Forest of Fontainebleau. Monet's technique is equally modern and akin to Manet's

FIG. I
Pointe de la Hève at Low Tide, 1865
Oil on canvas, 35½ x 59¼ in. (90.2 x 150.5 cm)
Kimbell Art Museum, Fort Worth, Texas

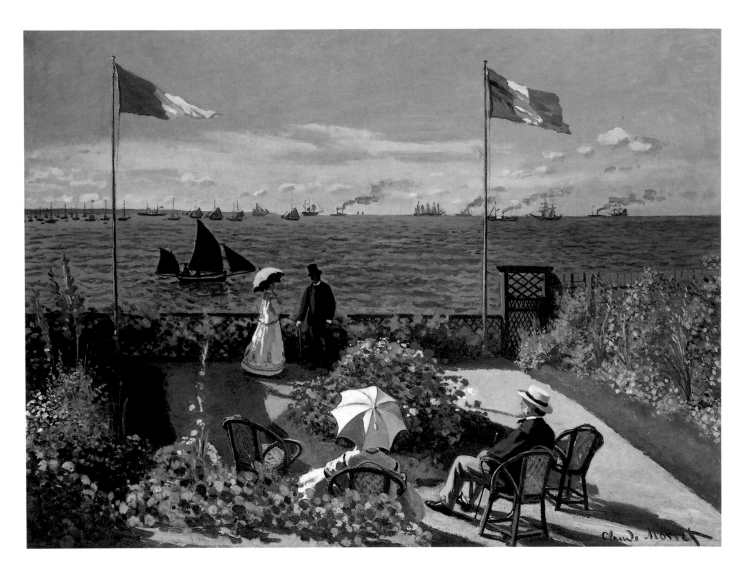

FIG. 2

The Terrace at Sainte-Adresse, 1866
Oil on canvas, 38 x 51 in. (96.5 x 129.5 cm)
The Metropolitan Museum of Art, New
York

broadly brushed style. But what was truly daring was Monet's intent to impart to his figural composition the sparkling plein-air effects previously seen only in landscape sketches. The sheer scale of the canvas defeated his plan, but fortunately a number of sketches and a fragment of the original canvas survive.[6]

Later in 1866 another figural composition of grand dimensions was begun, this one depicting elegantly contemporary women in a sun-dappled garden. Monet actually began *Women in the Park* (Musée d'Orsay, Paris) out-of-doors but had it transported to his studio in Honfleur for completion, when he could no longer pay for his lodgings at Ville d'Avray. Wanting to avoid previous logistical problems, Monet had a trench specially dug so that the eight-foot canvas could be lowered sufficiently for him to work on the topmost section. In his composition Monet did not rely on traditional tonal gradations to heighten the three-dimensionality of figures and drapery; instead, he employed broad areas of unmodulated color to approximate the flattening effect of strong outdoor light. The result is a simplification or abstraction of form and a conflict between two-dimensional pattern and three-dimensional illusion. *Women in the Park* was rejected by the Salon of 1867, and Monet never again attempted to paint on this scale out-of-doors. And not until his late water-lily paintings did Monet return to this grand scale.

Although he failed to win official sanction that year, 1866–1867 still proved to be a defining period for Monet. A series of sparkling works depict the quai by the Louvre in

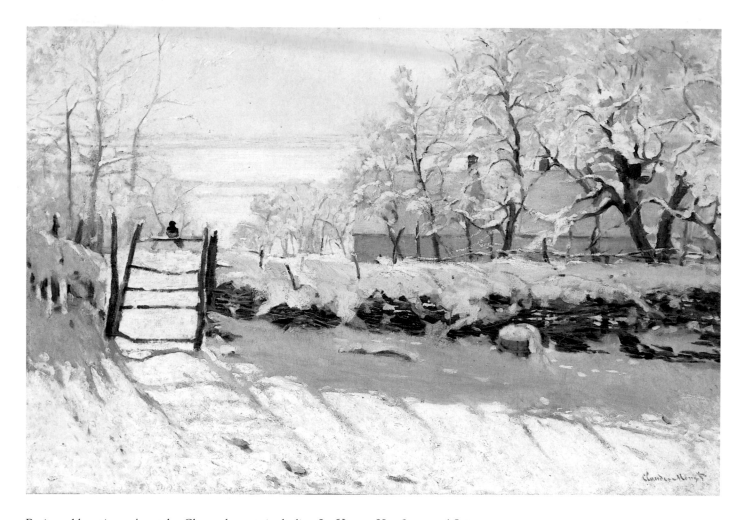

FIG. 3
The Magpie, ca. 1868–1869
Oil on canvas, 35 x 51⅛ in. (89 x 130 cm)
Musée d'Orsay, Paris

Paris and locations along the Channel coast, including Le Havre, Honfleur, and Sainte-Adresse, where his family had a house. *The Terrace at Sainte-Adresse* (fig. 2) is a composition startling for its suggestion of spontaneity and radiance of color, capturing the brilliant sunlit clarity of air possible only by the sea. The picture plane functions as a transparent window onto the painted scene; however, the boldness of the brushwork allows flat strokes of bright red, yellow, and green to stand alone on the surface, rather than to fall into place in the pictorial space. A scintillating tension between three-dimensional indicators and two-dimensional shapes results, which heightens the sense of animation already suggested by the flapping flags and smoke drifting in the distance. The scene's seemingly casual layout, with scattered points of interest instead of a primary focus, is, on examination, a very precisely controlled arrangement of the pictorial elements. Daring for the period, Monet's composition does not rely on conventional Western modes of pictorial arrangement. Rather, this is an early example of Monet's incorporation of design elements derived from Japanese prints, of which he was an avid collector.[7]

Working with Renoir and other friends, Monet continued to paint out-of-doors, closely observing and attempting to render the effect of bright light on surface shapes, colors, and shadows. Painting along the Seine, Monet explored different types of luminosity, such as light reflected off water. He also investigated on his canvases the varied

qualities of light characteristic of different times of day and in different atmospheric conditions. Unusual weather phenomena, such as snow and mist, fascinated Monet because they altered the chromatic appearance of familiar topography. In such paintings as *The Magpie* (fig. 3), one of Monet's early masterpieces, form dissolves under the combination of a greatly restricted color range, aerial perspective, and broken brushwork. A virtuoso color performance, the painting is an essay on the variations of white perceptible in the reflection of sun on crisp new snow. Wonderfully abstract passages of flat color, such as the strong violet shades along the fence, are divorced from the spatial realities of the objects portrayed.

In September 1870, following the outbreak of the Franco-Prussian War, Monet left Camille, whom he had married only three weeks earlier, and their son, Jean, who had been born in 1867, and fled to London, thus avoiding more unpaid hotel bills and military conscription. In England Monet met the London-based dealer Paul Durand-Ruel, who became his great champion and friend. Durand-Ruel promoted Monet's career, cementing the artist's reputation in London, Paris, and abroad, opening for Monet the lucrative market of the United States.[8]

FIG. 4
The Red Boats, Argenteuil, 1875
Oil on canvas, 24⅜ x 32⅜ in. (61.9 x 82.4 cm)
Courtesy of The Fogg Art Museum, Harvard University Art Museums. Bequest—Collection of Maurice Wertheim, Class of 1906

Returning to France via Holland in the autumn of 1871, Monet gathered his family and rented the first of a series of houses in small towns along the Seine, west of Paris. Thus began a period of intensive work and growing prosperity.[9] Residing in Argenteuil until 1878, Monet produced almost two hundred canvases of the scenery around him—the major thoroughfares and quiet lanes of the town itself, promenades and boating activities along the river, quiet backwaters of the channel called the Petit Bras, and the sweep of the poppy-strewn countryside around the town. These paintings represent the classical phase of impressionism, depicting the gifts of nature—sunshine, water, open fields, and flowers—but always, as in *The Red Boats, Argenteuil* (fig. 4), qualified by human activity, whether pleasure boats bobbing on the water or smokestacks in the distance. Such juxtapositions suggest, in Monet's paintings at least, a positive relationship between modern society's technological progress and its effect on the natural environment.[10]

Monet's most famous essays on industrialized power are the 1877 series of works representing the train shed at the Gare Saint-Lazare, a railroad station in northern Paris. In twelve canvases, including *Arrival of the Normandy Train, Saint-Lazare Station* (fig. 5), Monet captured his impressions of the vaporous beauty of the steam and smoke rising together to dematerialize the tangible power of the great locomotives, symbols of the modern age. In this group of paintings, Monet first experimented with the visual and

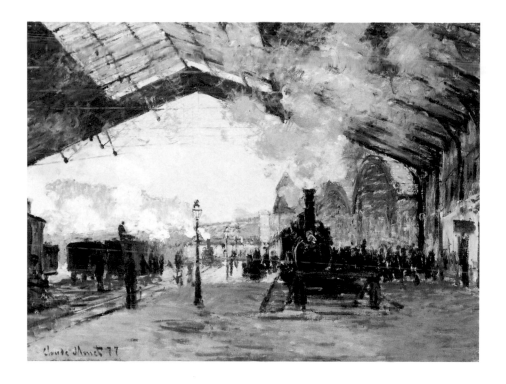

FIG. 5
Arrival of the Normandy Train, Saint-Lazare Station, 1877
Oil on canvas, 23½ x 31⅝ in. (59.6 x 80.2 cm)
The Art Institute of Chicago, Mr. and Mrs. Martin A. Ryerson Collection, 1933.1158.
Photograph © 1994, The Art Institute of Chicago. All rights reserved.

FIG. 6
Impression: Sunrise, 1872
Oil on canvas, 18⅞ x 24¾ in. (48 x 63 cm)
Musée Marmottan, Paris

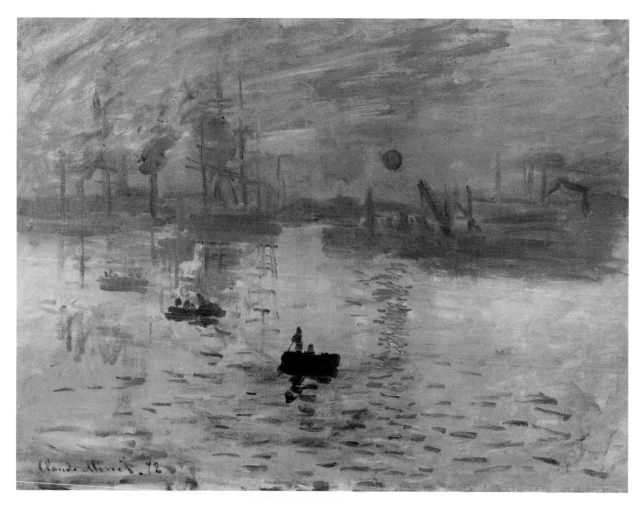

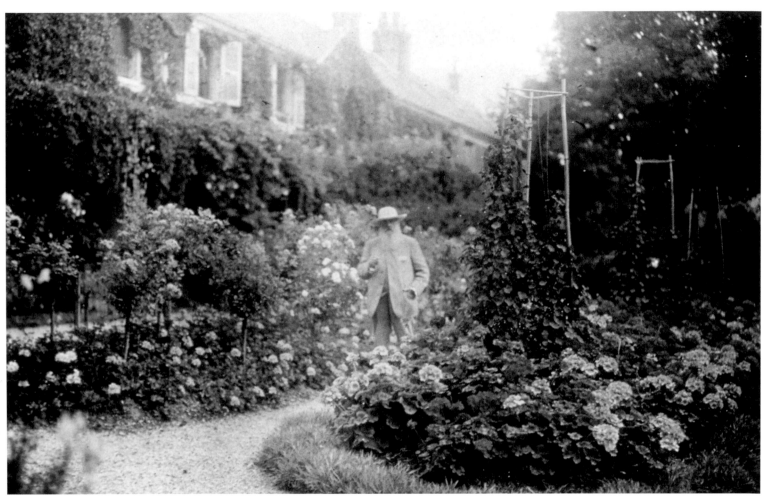

expressive potential of repetitions of a single motif. Each in the succession of canvases illustrates a different atmospheric condition or a different time of day. This approach would be perfected in the great series paintings of the 1890s.

Although Durand-Ruel began to buy Monet's paintings in quantity, Monet's commercial success did not translate into success with the Salon; from 1865 his paintings were alternately accepted (1865, 1866, 1868) and rejected (1867, 1869, 1870). Facing similar rejections, Monet's colleagues, Camille Pissarro, Sisley, and Renoir, joined with him and others to form a society of independents to show their works outside the Salon. Beginning in 1874 Monet exhibited with the Société Anonyme Coopérative d'Artistes-Peintres, Sculpteurs, Graveurs, whose eight collective exhibitions became known as the "impressionist" group shows.[11]

Occasionally Monet exhibited loose sketches alongside his more finished paintings. These freely brushed, economical sketches, executed out-of-doors, were called "impressions."[12] They suggest the directness of the artist's response to nature and his ability to render the most transitory effects. It was just such a painting, *Impression: Sunrise* (fig. 6), that attracted the critical attention of reviewers of the first group exhibition in 1874 and that gave the entire movement its name. In an animated review, Louis Leroy related a fictional conversation between two exhibition goers:

"Ah! This is it!" he cried in front of n. 98. "This one is Papa Vincent's favorite!
What is this a painting of? Look in the catalogue."
* "Impression: Sunrise."*
* "Impression—I knew it. I was just saying to myself, if I'm impressed, there must*
be an impression in there. . . . And what freedom, what ease in the brushwork!
Wallpaper in its embryonic state is more labored than this seascape!"[13]

This humorous piece and others helped to popularize the label "impressionist," which, of course, was actually a derogatory one stemming from an academic prejudice against the sketch in favor of the fully finished painting.[14]

Monet exhibited with his fellow impressionists in 1874, 1876, 1877, and 1879. However, in 1880 he again submitted two paintings to the Salon; only one was accepted and then it was hung too high to be viewed adequately. Subsequently, Monet refused to submit his works to the review of the conservative Salon jury. Although he was the impressionists' acknowledged leader, Monet's defection to the Salon of 1880 caused ill feelings among the central figures in the group.[15] These ruptures coincided with changes in artistic direction and in the group's membership and led to Monet's withdrawal from the impressionist group exhibitions; he exhibited in only one (1882) of the last four shows.[16]

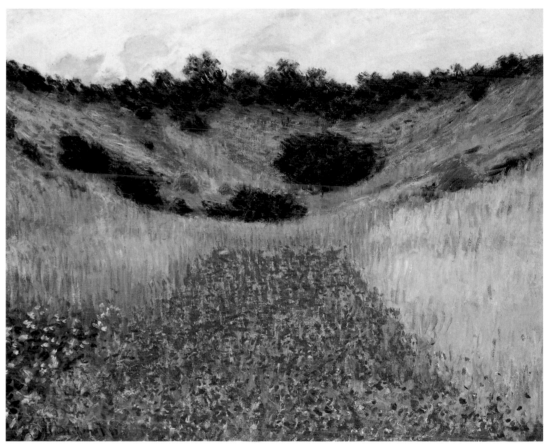

Fortuitously, however, at that moment developments in the art market provided Monet with new possibilities for the public exhibition of his paintings. The one-man show, previously a rare occurrence, was gaining acceptance in Paris. Courbet had been among the first to show his works in this fashion; Manet and Renoir had recently been featured in solo shows in the offices of the periodical *La Vie moderne*, sponsored by Renoir's patron Georges Charpentier. Monet's first solo exhibition opened in June 1880, the third in Charpentier's series. From then on, the individual show was the vehicle by which Monet brought his recent works to public attention. Taking an increasingly prominent role in the promotion of the works of living artists, it was the art dealer who provided other opportunities for independents like Monet. Working in conjunction with the dealers Durand-Ruel, Georges Petit, and Theo van Gogh, and at times playing one against the other, Monet benefited from the twin advantages of more artistic control over the manner in which his paintings were presented and a more reliable method to market them.[17]

FIG. 8
Poppy Field in a Hollow near Giverny, 1885
Oil on canvas, 25⅝ x 32 in. (65.2 x 81.2 cm)
Juliana Cheney Edwards Collection. Courtesy, Museum of Fine Arts, Boston

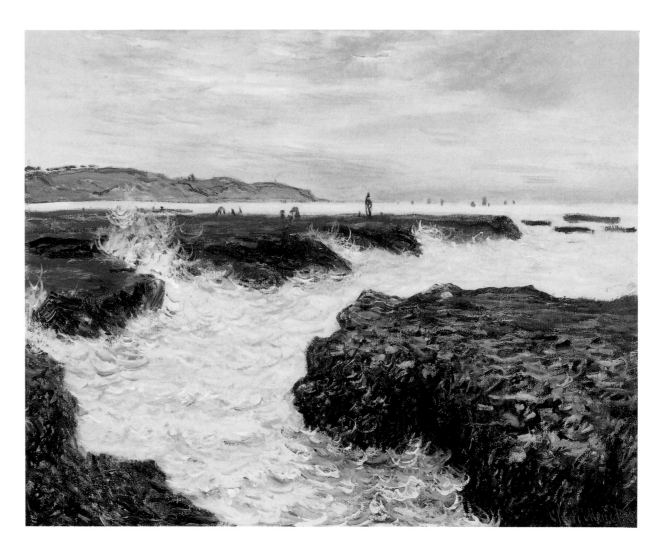

FIG. 9
The Rocks at Pourville, Low Tide, 1882
Oil on canvas, 25⅝ x 31 in. (65.1 x 78.7 cm)
Memorial Art Gallery of the University of
Rochester. Gift of Emily Sibley Watson

Leaving Argenteuil in 1878, the growing Monet household moved several times during the next few years, first to Vétheuil, Poissy, and finally in 1883 to the pink stucco house in Giverny (fig. 7), where the artist lived until his death.[18] Unlike the relatively quiet years in Argenteuil, during which Monet traveled only infrequently beyond the Paris region, the 1880s was a period of extensive travel. While familiar scenes of the countryside, such as poppy fields near Giverny (fig. 8), continue to appear, the artist sought varied and dramatic new scenery for his canvases. He undertook long campaigns in Normandy at Etretat, Fécamp, and Varengeville; off the coast of Brittany among the rock formations at the island of Belle-Isle; and in the rugged Creuse valley of France's Massif Central. In works from these regions, such as *The Rocks at Pourville, Low Tide* (fig. 9), Monet chose the most expressive juxtapositions, creating compositions that accentuate the dramatic opposition of natural forms and forces. Exhibiting an almost obsessive fascination with certain viewpoints, such as the Needle Rocks at Belle-Isle or the convergence of the Petite and Grande Creuse rivers, near Fresselines,[19] Monet painted them numerous times. His forceful technique of vigorous brushstrokes evokes the patterns of the natural elements depicted, such as jagged rocks awash in surging tides. These groups of paintings of the 1880s exhibit densely built-up surfaces very different from the more delicately worked surfaces of earlier canvases. In this and in

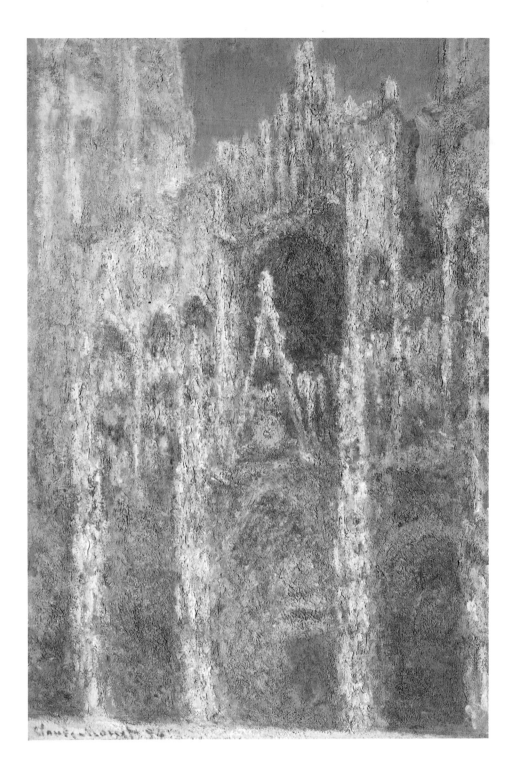

the wide range of visual effects depicted, these paintings anticipate the innovative series
Monet would create in the 1890s.

In 1891 Monet exhibited twenty-two paintings in a solo show at the Durand-Ruel
Gallery; fifteen of the paintings were variations on one theme: grainstacks.[20] This was
the first of a succession of series paintings, each series magical interpretations of a
recurrent motif viewed under differing conditions of atmosphere and light. Striving
to evoke what he termed the "enveloppe," or external appearance of his subject, Monet
initially worked very quickly and briefly on each canvas, staying with it only as long
as that certain effect lasted.[21] After his initial "impression" was captured out-of-doors,

FIG. 10
Rouen Cathedral, Façade, 1894
Oil on canvas, 39⅞ x 26 in. (100.6 x 66 cm)
Juliana Cheney Edwards Collection. Courtesy,
Museum of Fine Arts, Boston

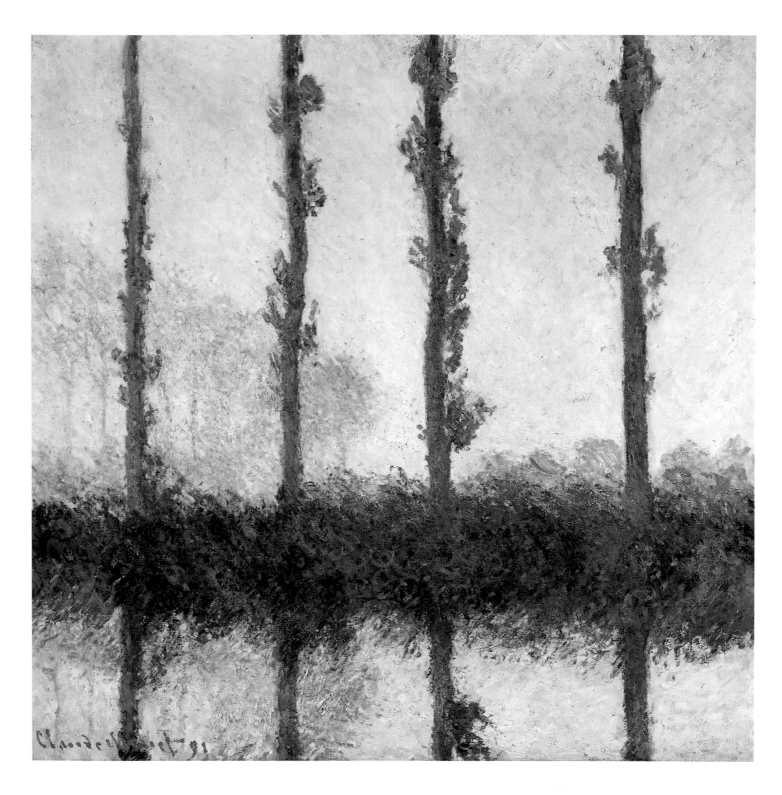

FIG. 11
The Poplars, the Four Trees, 1891
Oil on canvas, 32¼ x 32⅛ in. (81.9 x 81.6 cm)
The Metropolitan Museum of Art, New York

Monet spent long periods of time in the studio working to bring the entire suite of paintings into chromatic harmony. This working and reworking of the surface led to a very thick build-up of the paint layers. In paintings such as *Rouen Cathedral, Façade* (fig. 10) from the renown *Rouen Cathedral* series, the pictorial surface is literally encrusted with layers of the most sophisticated nuances of color. The picture plane, previously transparent like a pane of glass, has become thick and opaque, an obstacle to our entry into the space.[22]

The inventiveness of these series is astonishing, with the artist flirting with various types of abstraction of form and simplification of pictorial composition. In *The Poplars, the Four Trees* (fig. 11), for example, Monet has cut off the tops of the trees, scoring the picture plane with a grid of horizontals and verticals. Without adequate reference to foreground, background, or horizon line, the viewer cannot read the image three dimensionally, except for the suggestion of foliage spiraling around the tree trunks; the canvas has lost that illusion of depth sought by generations of Western artists. This sensation of conflict and competition between two-dimensional pattern and three-dimensional objective form was further developed by Monet during the last twenty-six years of his life, when he turned his eye and his brush to painting the gardens of Giverny. Although Monet always maintained that nature was his ruling inspiration, his late work was in turn inspirational to artists interested not in the natural world but in the formal world of abstraction. With these adventuresome works, we stand on the brink of the modern disregard for a recognizable subject: objective reality is dispensed with so that the artist is free to concentrate on the expressive power of shapes and colors.

Passion and Patriotism in Monet's Late Work

Paul Hayes Tucker

n 17 March 1893, almost ten years to the month after he had left the Paris region to settle in the rural hamlet of Giverny some sixty kilometers northwest of the capital, Monet wrote the local departmental prefect a brief but revealing letter. The then fifty-three-year-old artist requested permission to install a *prise d'eau*, or water trough, in the Epte river near his property in the heart of the village. This trough would allow "for a small, intermittent diversion [of water]," which Monet claimed would not alter the level or the flow of the river. It would merely provide enough water to refresh the pond he was going to dig on his property "with the eye to cultivating aquatic plants," as he described it to the official. Monet also asked the prefect for permission to build two "small, light, wooden bridges over the tributary to the Epte in order to go from one bank to the other and vice versa."[1]

These relatively modest requests initiated what would become one of Monet's most grandiose works of art and one of the most celebrated horticultural projects in all of France, namely Monet's now famous water-lily garden (fig. 1). His proposals prompted swift protests from local residents. This odd Parisian was going to drain too much water from the river, they claimed, and would then contaminate the Epte with his exotic cultures, which the Givernois distrusted since the plants were not local species. When he learned of these complaints, Monet became furious. "The hell with the natives of Giverny and the engineers," he raged to his wife, Alice Hoschedé. "I don't need to hire any of them nor order any lattice. Throw all of the aquatic plants in the river."[2] After two hearings on the matter over the next two months, another letter from Monet to the prefect in which the painter defended his plans again, and the support of a former publisher of an influential Rouen newspaper whom Monet had contacted, the prefect finally granted the artist his requests in July and issued the appropriate building permits.

These events attest to Monet's tenacity in the face of opposition and his ability to operate effectively as a political being. They also reveal how sharp-tempered he was and how differently he saw himself in relation to his neighbors. But most important, they demonstrate his steadfast commitment to his vision, one that would preoccupy him for the remaining thirty-three years of his life and result in a spectacular legacy. For not

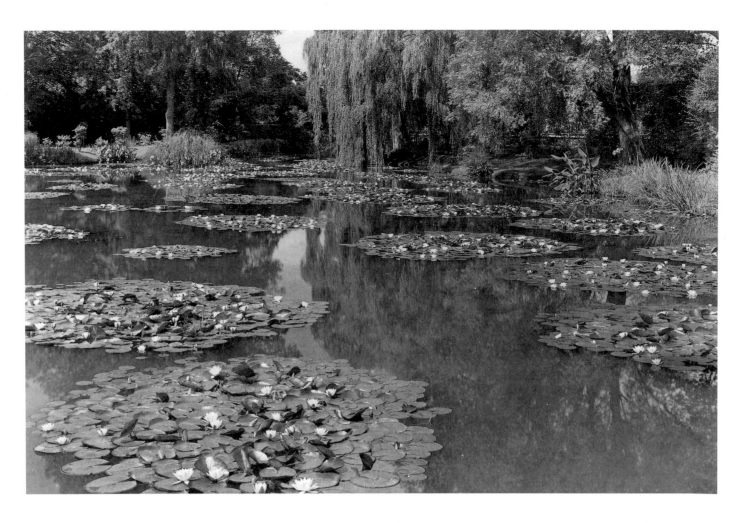

FIG. 1
The full length of the water-lily pond, ca. 1933
Photograph
Country Life Picture Library, London

only did Monet create a site that today is one of the most visited in France, he also completed over 250 paintings that depict various aspects of this garden paradise. Some of the most breathtaking canvases of this immensely varied group happily form the basis of this marvelous exhibition.

Monet's keen interest in constructing his water-lily pond was only the most ambitious manifestation of a long-standing passion for gardening. More than two decades before he began digging the pond, for example, he had devoted considerable time and resources to gardens that were part of properties he rented in Argenteuil, a close suburb of Paris, where Monet lived between 1871 and 1878 (fig. 2; see also Murray, fig. 2). Even when funds were short during that decade, he made sure his garden flourished. And when he left for Vétheuil, where he settled in 1879, he was careful to choose a house that came with acreage that he could fill with flowers and potted plants (fig. 3). Naturally, his art reflected this horticultural fervor. Of the more than eight hundred paintings he completed during the first half of his career before moving to Giverny in 1883, over one hundred are views of sun-dappled gardens or flower-rich still lifes that bear witness to his botanical handiwork. Little wonder, therefore, that he once told an interviewer, "more than anything, I must have flowers, always, always."[3]

It was Monet's estate at Giverny, however, that provided him with the ultimate in gardening opportunities. When Monet leased the property in April 1883, the garden that stretched out in front of the large pink stucco house was a traditional Norman kitchen garden, where the previous occupants grew their fruits and vegetables. It was the first thing to go when Monet finally purchased the property in 1890, visual beauty quickly

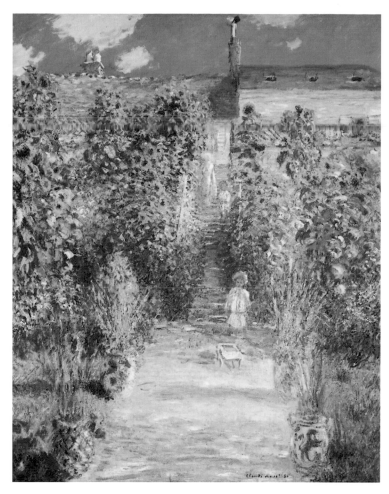

replacing practicality. The fruit trees and berry bushes were uprooted, the vegetables plowed under, and the whole was completely redesigned. Sand paths were imposed on the almost two-acre plot and dozens of planters raised on either side of the garden's main alley, which was lined with trellises to support climbing roses. The fertilized beds were sown with a spectrum of flowers that were coordinated to bloom continuously from early spring until late fall (fig. 4).

The water garden lay about thirty paces from this floral fantasia, on the other side of the road and the railroad tracks that ran through the property. In 1883 the water garden consisted merely of a pond that sat in a meadow outside the boundaries of Monet's estate. In 1893 he purchased the land, and, after receiving the prefect's approval in July to divert the waters from the Epte, he hired his construction crew and began work. The whole project was completed sometime late that fall. Covering approximately one thousand square meters, the water pond was soon ringed by an artful arrangement of flowers, trees, and bushes, crossed by a Japanese-style wooden bridge, and filled with water lilies. Monet eventually enlarged the pond several times (in 1901, 1903, and again in 1910), expanded its plantings, added a trellis to the Japanese bridge, and removed the concrete that he had originally poured for a floor in part of the pond.

In many ways, the two gardens were perfectly paired. The flower garden was more traditional and more Western. It harked back to designs for formal, country-house gardens that had been devised in the eighteenth century. The water-lily garden was more Eastern, with its more natural layout, reflective waters, and Japanese bridge. It also contained many Eastern plantings—bamboo and ginkgo trees, for instance, as well as

FIG. 2
Camille in the Garden of Monet's House at Argenteuil, 1876
Oil on canvas, 32⅛ x 23⅝ in. (81.6 x 60 cm)
From the Private Collection of The Hon. and Mrs. Walter H. Annenberg

FIG. 3
The Artist's Garden at Vétheuil, 1880
Oil on canvas, 59⅜ x 47⅝ in. (151.4 x 121 cm)
National Gallery of Art, Washington, D.C.
Ailsa Mellon Bruce Collection, ©1994 Board of Trustees

Japanese fruit trees. Silent and meditative, mysterious and foreign, it visually and emotionally was quite different from the bolder, more profuse flower garden across the tracks (figs. 1, 4).

It would be wrong to think of the two gardens as polar opposites, however, as the water garden also contained plenty of Western trees and bushes and had been designed with as much rigor as the seemingly more geometric flower garden. Conversely, there

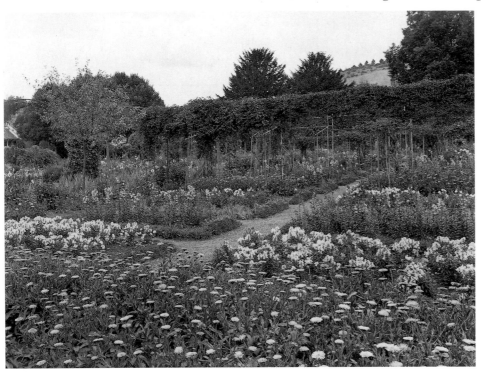

were Eastern plantings in the flower garden, and its strict geometry was intentionally disguised by nasturtiums and wild geraniums that softened the edges of the planters and by aubretia and pink saxifrage that spilled out onto the intersecting paths. In the end, the two gardens were two complementary ways to appreciate the beauties of nature, thus affording Monet a wide range of visual incidents to paint. "Everything I have earned has gone into these gardens," he once told an interviewer. "I do not deny that I am proud of [them]."[4]

Given his devotion to these gardens, it is curious that Monet did not paint either of them seriously until 1899, when he began a group of what would become eighteen views of the Japanese bridge, twelve of which he exhibited in Paris in late 1900 (fig. 5). He might have wanted to wait until his plantings matured. A photograph of the Japanese bridge taken around 1895 shows the pond to be rather sparse (fig. 6). Monet also had not painted garden scenes in quite

FIG. 4
The flower garden, ca. 1933
Photograph
Country Life Picture Library, London

some time, preoccupied as he had been with very different subjects. In the 1880s he gave up painting scenes of modern life and traveled extensively to work at sites from the north of the country to the south—Belle-Isle in the Atlantic off the Brittany coast, the Creuse valley in the Massif Central, and picturesque locations along the Mediterranean.

These campaigns allowed Monet the opportunity to reveal the flexibility of his impressionist style as well as his dexterity as an artist. They also demonstrated impressionism's responsibility to the nation as a whole, thus breaking the ties it had always had to Paris. With a wealth of new material to show from these travels every few years, Monet could also maintain his position at the forefront of avant-garde landscape painting, something that was constantly challenged during the decade by a host of competing concerns, from Georges Seurat and the neo-impressionists to Paul Gauguin, Paul Sérusier, and the synthesists. This competitive environment led Monet in 1888 and 1889 to devise the novel idea of painting pictures in series. Concentrating on a single subject and rendering it over and over again under different lighting and weather conditions would silence critics who claimed impressionism was practiced by mindless individuals who applied paint in a spontaneous, haphazard fashion. Beginning with his *Grainstacks* of 1888 to 1891, these series pictures brimmed with rigor and beauty. They were serious paintings done by a mature artist who was immensely sensitive not only to the nuances of nature but also to the intricacies of his craft. The *Grainstacks* were greeted with great enthusiasm when Monet showed fifteen of them in 1891. So were the subsequent series of

FIG. 5
Water-Lily Pool, 1900
Oil on canvas, 35⅜ x 39¼ in. (89.9 x 101 cm)
The Art Institute of Chicago. Mr. and Mrs. Lewis Larned
Coburn Memorial Collection, 1936.441. Photograph ©1994,
The Art Institute of Chicago.

FIG. 6
The water-lily pond and the Japanese bridge, ca. 1895
Photograph
Lilla Cabot Perry Papers, Archives of American Art,
Smithsonian Institution

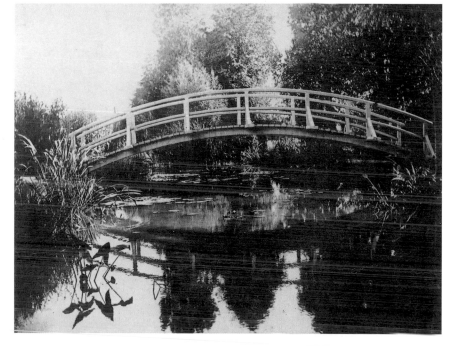

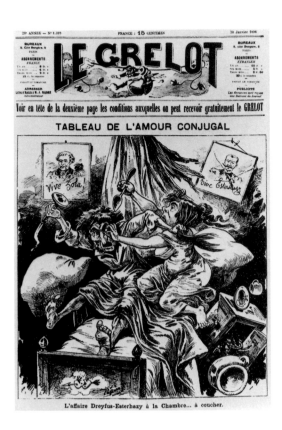

FIG. 7
Pépin
A Portrait of Conjugal Love
(*Tableau de l'amour conjugal*)
Le Grélot, 30 January 1898
Photomechanical print
Bibliothèque Nationale, Paris

Poplars, Rouen Cathedral, Cliffs, and *Mornings on the Seine,* which followed one after another with extraordinary aplomb. These series paintings earned Monet huge amounts of money and unprecedented accolades from critics who spanned the political spectrum. According to Camille Mauclair, the symbolist spokesperson, Monet was "the premier painter of his era"; for the republican-anarchist Georges Lecomte, he was "one of the crowning jewels of our epoch"; for the conservative Raymond Bouyer, he was "the most significant painter of the century."[5]

Why these series paintings were so well received is a complicated tale, but one of the primary reasons is also one of the most obvious. In addition to being extremely accomplished, the paintings focused on subjects that were laden with meaning for Monet's countrymen and -women. Most of them touched nationalistic chords because of their evident Frenchness, as with the *Cathedral* paintings, or because they evoked the French tradition, as with the *Mornings on the Seine,* which so strongly recalled paintings by Camille Corot. As one critic pointed out after seeing the series during the decade, "Monet's work above all expresses France, at once subtle and ungainly, refined and rough, nuanced and flashy. . . . [H]e has expressed everything that forms the soul of our race."[6]

Although gardening was a national pastime and landscape architecture a long-standing art form, paintings of one's own backyard could not engender the same kind of reaction as these evidently nationalistic subjects, no matter how beautiful Monet's plantings may have been. Wanting to achieve national stature, Monet thus did not turn to paint his water and flower gardens until the decade was nearly over and he had secured his position in the annals of French art.

It is perhaps no coincidence, however, that this turn occurred not only after his rise to prominence but also just after one of France's greatest national tragedies—the heinous Dreyfus Affair, which began in 1894–1895 when Alfred Dreyfus, a Jewish captain in the French army, was found guilty of selling military secrets to the Germans and was sentenced to life imprisonment on Devil's Island off the coast of South America.[7] When new evidence was discovered that suggested a certain Colonel Esterhazy was the perpetrator and that Dreyfus was innocent, the army was forced to reopen the case. It brought Esterhazy to trial in January 1898 and after barely two weeks found him not guilty. The decision divided the nation and pitted family and friends against each other, providing caricaturists with ample fodder for satire (fig. 7). It also brought out a bitter anti-Semitism that had lurked below the surface for years. The Left decried what it saw as a gross miscarriage of justice and the ultimate example of a fundamentally corrupt system. The Right defended the army, believing no Jew could be trusted, particularly when it came to issues of national security. When the Right took up a collection for the widow of another army officer who was implicated in the scandal and who had committed suicide to avoid embarrassment, 25,000 francs poured in from all over the nation in donations of ten and twenty francs, often accompanied by stingingly racist notes.

When Emile Zola defended the ill-accused Dreyfus in three articles culminating in his inflammatory "J'accuse" (which Georges Clemenceau published on the front page of his newspaper *L'Aurore* on 18 January 1898 just after the court martial's decision), the novelist was charged with libel, tried, and found guilty. He was sentenced to a year in prison and fined three thousand francs. To avoid the penalty and the humiliation, Zola fled to England, where he remained for over a year.

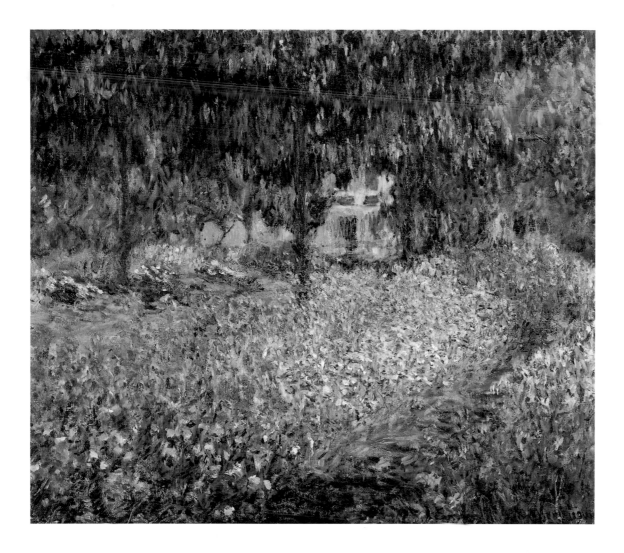

FIG. 8
The Artist's Garden at Giverny, 1900
Oil on canvas, 31⅞ x 36¼ in. (81 x 92 cm)
Musée d'Orsay, Paris. ©, PHOTO R.M.N.

Unlike Degas and Renoir who became staunch anti-Dreyfusards, Monet wrote to Zola several times after his articles appeared, praising the novelist for his strength and initiative. "Bravo and bravo again for the two beautiful articles!" he hailed him in December 1897. "You alone have said what must be said and you have done it so well." The day after "J'accuse" appeared, Monet wrote his old friend again. "Bravo once again," he exclaimed, "and all of my heartfelt sentiments for your valor and your courage." Monet even planned to attend Zola's trial but became burdened with sick family members. "I have followed this disgraceful trial from afar, and with passion," he wrote his friend and supporter, Gustave Geffroy. "How I would like to be there! You must be disheartened and saddened by the conduct of many people, and of the newspapers above all; they are so vile." The following day, he wrote Zola once more. "Sick and surrounded by others who are ill, I could not come to your proceedings and shake your hand, as had been my desire. That has not stopped me from following all of the reports with passion. I want to tell you how much I admire your courageous and heroic conduct. You are admirable. It is possible that when calm is restored, all sensible and honest people will pay you homage. Courage, my dear Zola. With all my heart."[8]

These rare expressions of Monet's liberal politics are significant as they boldly attest to his disdain for his government's actions. His decision to devote himself to

painting his gardens, therefore, stands to reason. He simply could not continue to propagate idealistic notions about his country when its leaders had shown themselves to be so fundamentally corrupt and the nation so helplessly embroiled in a debate that had such hypocrisy at its core. Pissarro, who was equally hurt by the affair, could tell his son that he was going to sit at his hotel window in Paris and work as if nothing had occurred, but Monet was of a different ilk.[9] From 1898 until his death in 1926, he painted over five hundred pictures; only a dozen depict a recognizable French site. The sordidness of the affair caused Monet to give up his lifelong project of immortalizing his native land and to retreat into a world of his own making.

By focusing almost exclusively on his gardens, Monet was not emptying his art of meaning. Just the opposite. Whether rendering his floral fantasia or his water-lily pond (figs. 8, 9), he asserts the primacy of an individual vision and each person's ability to find significance in the elemental relation of the human to the natural. Plumbing it over and over again in these endlessly engaging garden pictures, Monet insists that individuals can begin to understand more fully the complexities of the most awesome force in the world, to appreciate its beauty and to respect its power. Such an understanding nurtures individual growth, allowing people to come to know themselves better, to recognize their place in the larger whole, and, ultimately, to act more responsibly in a world that appeared to Monet, at the end of the 1890s, to have abandoned that obligation.

Monet suggests these messages not only in the subjects he chooses, which initially appear so innocent and free, not only in his utter devotion to those subjects for more than a quarter of a century, but also in the way he handles them, particularly over time. For in addition to editing from his paintings all evidence of the world beyond his garden walls, thereby suggesting the potential existence of an Eden on earth, Monet continuously draws attention to the constructs of his art. In the water lilies, for example, such as catalogue numbers 3, 6, and 7, he establishes intricate dynamics between one lily pad

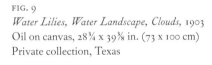

FIG. 9
Water Lilies, Water Landscape, Clouds, 1903
Oil on canvas, 28¾ x 39⅜ in. (73 x 100 cm)
Private collection, Texas

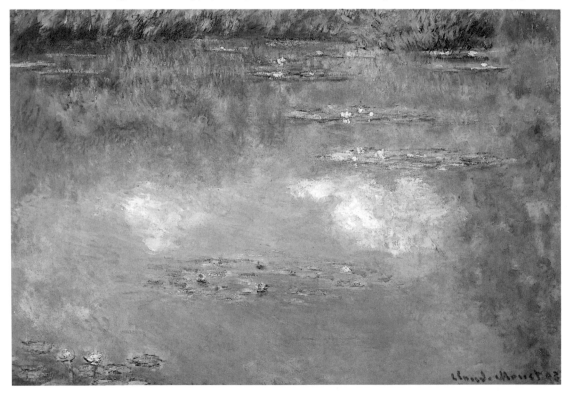

and another, between the water flowers as a group and the surface of the pond, between the pond and the surrounding banks, and between the pond and elements outside the scene —branches, foliage, clouds, and sky— which are seen reflected on the pond's surface. In the views of the flower garden he ignites a similar charge between individual flowers and between groups of writhing petals and the paths which cut through the scenes, heightening the pictures' illusionary depths.

In both kinds of garden pictures, he constantly reinforces the basic tensions that exist in the art of painting— between the surface of the canvas and the space he carves out of it, the flatness of the images and their plastic qualities, the strokes on the canvas and their multiple associations. In earlier water-lily pictures, for example (figs. 9, 10; see also cat. nos. 1, 2), he increasingly tilts the image up on the canvas until it finally pushes distant reference points out of the scene and lays claim to the surface as a whole. He also experiments with various formats—squares, vertical rectangles, even circles. And he often builds up his images in such a manner that the layers of paint actually allude to the spatial dimensions of the scene being described.

But the most dramatic and perhaps the most moving evidence of Monet's desire to bare the principles of his processes and thus heighten both the relationship of the viewer to the natural world being depicted and the ways in which painting can communicate ideas comes with the canvases from the last twelve years of his life. Numbering nearly two hundred, these paintings are characterized by an unprecedented breadth in terms of their size, touch, and expansiveness of vision. Given their combined square footage, no less the bravura with which they are executed, it is hard to believe Monet was in his seventies and eighties when he completed them. Some measure more than nineteen feet long by six feet high (fig. 11). So big are they that we cannot even see them in a single glance. Instead, we are obliged to scan them from side to side and from top to bottom, causing us to act like the strokes of paint themselves, moving with independence and calculation back and forth across the surface and in and out of its multiple skeins of color and line. Other pictures, such as those that depict the rose-trellised path that led to his house or the Japanese bridge over the water garden across the street (fig. 12), are so densely painted with such high-keyed color that they almost abandon their function as defining mechanisms and become evocative suggestions of pure sensory experience. As the critic Roger Marx remarked in an imaginary interview with Monet, they were like Debussy's music; they "succeed in touching us, as a musical phrase or chord touches us, in the depths of our being, without the aid of a more precise or clearly enunciated idea."[10]

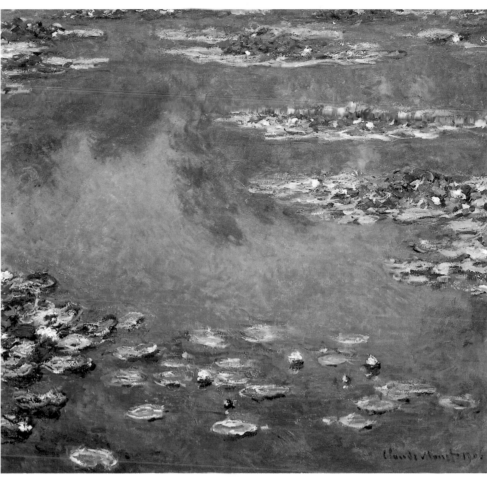

FIG. 10
Water Lilies, 1906
Oil on canvas, 34½ x 36½ in. (87.6 x 92.7 cm)
The Art Institute of Chicago. Mr. and Mrs. Martin A. Ryerson Collection, 1933.1157. Photograph ©1994, The Art Institute of Chicago. All rights reserved

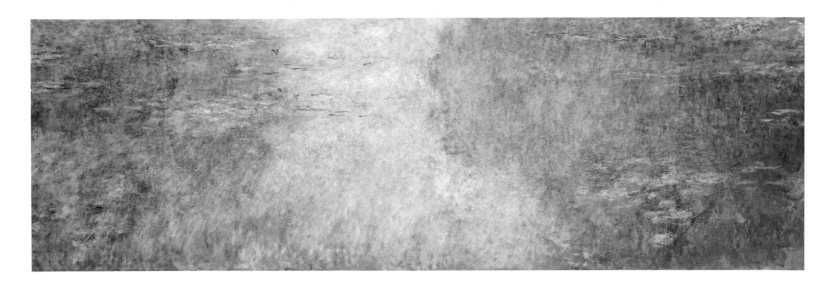

FIG. 11

Water Lilies, ca 1920
Oil on canvas, 78½ x 235½ in. (199.5 x 599 cm)
The Museum of Modern Art, New York. Mrs.
Simon Guggenheim Fund. Photograph ©1994
The Museum of Modern Art, New York

Virtually all of these pictures, however, are not just deeply felt or romantically symphonic; they are also the product of Monet's intense conviction about their viability as objects and their ability to convey meaning on many different levels. While this can be sensed standing in front of them, it is confirmed over and over again in Monet's letters. For to him, these paintings were not merely the culmination of his lifelong preoccupation with light, color, and instantaneity, as they are so often portrayed. They had larger dimensions. He completed them in the huge expanse of the studio, for example, that he had built just next to his house. They are therefore as much about memory as they are about observation, and they are as engaged with ideas of creation as much as they are representations of specific elements in the world. They are also as deeply involved with history as they are witnesses to their particular moments in time. As such, they attest to Monet's keen sense of himself in relation to notions of change and stability and the intermingling of the past and the present. Time and history had always been critical to his enterprise. Here, these two phenomena are stretched forward and backward as Monet suggests that they are at once frozen and continuous, terrifying and reassuring, much like his paintings, indeed, much like life in the modern age.

All of these ideas make the paintings magisterial; but they also make them seem impossible, as if rhetoric here is overwhelming reality. Support for these ideas, however, is again found in the paintings. For like the series pictures of the 1890s, these water lilies and rose-covered pathways—particularly the late versions—clearly speak on many levels. They are virtually obliged to do so given their imposed limitations—their compressed space, narrow focus, insistent borders, and circumscribed color schemes. Monet appears to have reduced painting to radical essentials in an effort to allow those elements of art making to speak on their own terms across time and space, to operate in effect like a new and different kind of language, one that is not bound to a specific discipline, person, nation, or tradition. In the same multivalent manner, it is as if Monet himself were operating as an amalgam of other personae—sculptor, musician, poet, magician, jester, wise man, soothsayer, seeker.

No matter how much these canvases may appear to cut their ties to history, however, they still are inevitably locked into the complex of forces that shaped Monet's moment. And it is from that complex that they gain what might be their ultimate power.

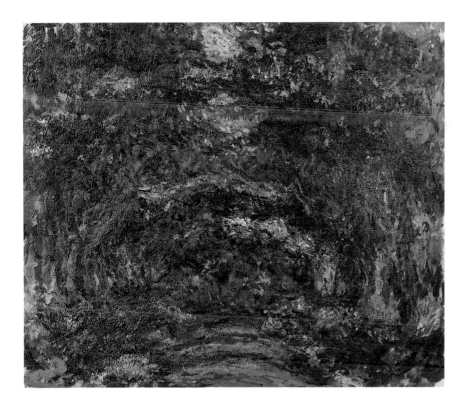

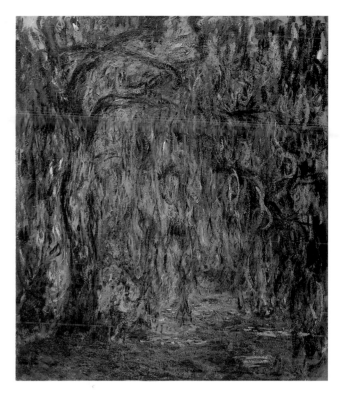

The majority, for example, were begun as Frenchmen marched to the front in August 1914 to defend their country once again against the invading Germans to the east. Monet's son Michel and his stepson, Jean-Pierre Hoschedé, both eventually joined that devastating conflict, leaving the old man alone in Giverny with his daughter-in-law Blanche Hoschedé for long periods of time. Work for Monet had always been "the great consoler," as he admitted to Durand-Ruel in June 1914, but with the outbreak of the war less than two months later, it took on even more heroic dimensions, just as his canvases grew in size and grandeur. "It's still the best way of not thinking about present sorrows," he wrote to Geffroy in December of that fateful year, "although I'm rather ashamed of thinking about little researches into forms and colors while so many suffer and die for us."[11] Like his younger contemporary Matisse, who openly admitted that he would contribute to the war effort by making art, Monet stood steadfastly by the banks of his pond doing what he knew how to do best. And just like the canvases that came out of Matisse's Paris studio at the time, Monet's pictures of 1914–1918 are not only continued explorations of painting's formal possibilities; they also are cries of anguish and odes of determination, yearnings for beauty and hopes for resolution. Thus, willow trees shake in the violence of the light, their long tousled foliage flowing like rivulets of tears or chills of celebration (fig. 13). Reflections of those quivering leaves veil the pond in other pictures, providing both a sense of reassurance and an element of ill ease (fig. 14; see also cat. no. 10). There is little comfort, in fact, in many of these pictures; the surfaces are agitated, the brushwork aggressive; colors are harsh, even acidic. The struggle for harmony was clearly hard fought, much like those that were being waged throughout France at exactly the same time.

The convergence of these events—the horrors of the Great War and the heroic efforts of an aging artist to create a new form of beauty—was fortuitous, of course, as history often is. It might be said, however, that it was even more so in this case. Nearly twenty years earlier, Monet had actually envisioned a decorative project similar to the

FIG. 12
Path in Monet's Garden, 1918–1924
Oil on canvas, 35 x 39⅜ in. (89 x 100 cm)
Musée Marmottan, Paris

FIG. 13
Weeping Willow, 1918
Oil on canvas, 51⅝ x 43½ in. (131.1 x 110.5 cm)
Columbus Museum of Art, Ohio. Gift of Howard D. and Babette L. Sirak, the Donors to the Campaign for Enduring Excellence, and the Derby Fund

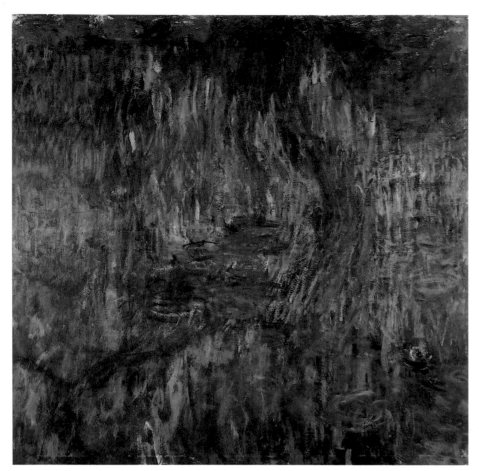

one that was taking shape during the war, as is evident from a conversation he had in 1897 with the journalist Maurice Guillemot. "Imagine a circular room," he told Guillemot, who was visiting the artist in Giverny, "the dado below the wall molding entirely filled with a plane of water scattered with these plants, transparent screens sometimes green, sometimes mauve. The calm, silent, still waters reflecting the scattered flowers, the colors evanescent, with delicious nuances of a dream-like delicacy."[12]

The notion may have been similar to what Monet nurtured during the war, but its realization could not have been more different, as the eight canvases Monet completed between 1897 and 1898 to test his idea are a far cry from those that emerge from 1914 onward. Compare figures 14 and 15, for example. Smaller in scale and significantly reduced in palette, brushwork, and ambition, figure 15 appears almost lifeless in comparison to its later cousin. The same could be said about most of the water-lily paintings that Monet executed between 1903 and 1909. Although there are notable exceptions, the majority of these serene canvases are dominated by a lighter, clearer palette, a pearly kind of light, and a greater sense of reverie, than what would follow from the war years onward, as is evident when figure 9 or 10 is compared with figure 11 or 14 or with the later water-lily paintings in the present exhibition (cat. nos. 6, 7). The later *Japanese Bridge* paintings and views down the central path of Monet's flower garden are also quite different from their earlier counterparts, which are much more descriptive and precise than the tumultuous canvases of twenty years later. Compare figures 8 and 12, for example. There is a seriousness and an urgency that invade all of these paintings beginning in 1914, as if the ante had been upped and the challenge had become more intense.

Undoubtedly, some of this change was due to Monet's advancing age. Though vigorous to the end, he knew his time was limited. This unavoidable fact was brought home to him all too often as the years elapsed. By the outbreak of the war he had witnessed the passing of most of his generation—Caillebotte in 1894, Morisot in 1895, Sisley in 1899, Pissarro in 1903, and Cézanne in 1906. With Degas's death in 1917 and Renoir's in 1919, he became the last surviving impressionist. During this same period, Monet lost members of his own family. His stepdaughter, Suzanne, died in 1899; his second wife, Alice, Suzanne's mother, died in 1911; and Monet's first son, Jean, died in 1914. In addition to enduring these tragedies, the man who relied so heavily on vision developed cataracts in both of his eyes in 1912. They became progressively worse until he was finally diagnosed in 1922 as having 10 percent vision in one eye and the ability in the other only to see light when strongly projected. Although he never complained about his problem until 1919, it had to have haunted him. It certainly became a preoccupation until he had the cataracts removed in 1923 and recovered full sight shortly thereafter (fig. 16).

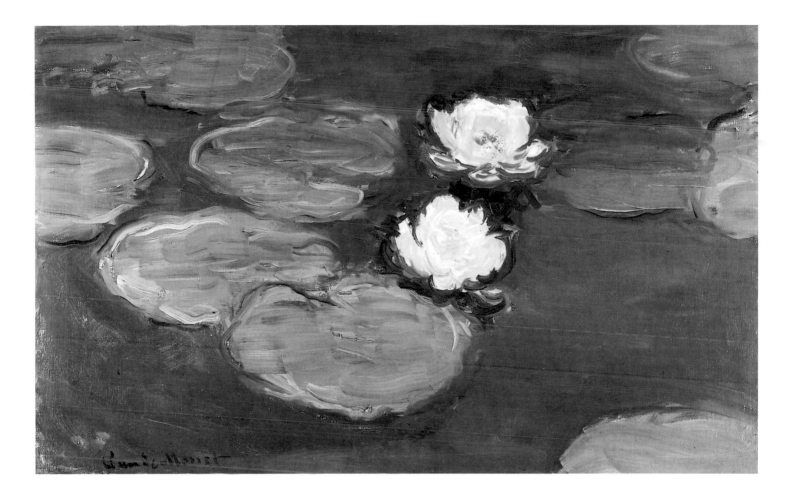

FIG. 15
Water Lilies, 1897–1898
Oil on canvas, 26 x 41 in. (66 x 104.1 cm)
Los Angeles County Museum of Art. Bequest of
Mrs. Fred Hathaway Bixby

The intensity with which he took up his painting campaign also surely has something to do with the fact that impressionism had long been overtaken as an avant-garde style by the rapid succession of advanced movements at the beginning of the century—fauvism, cubism, orphism, and futurism, and, during the war, by purism, De Stijl, and dada. Monet's distance from the forefront of artistic production must have weighed on the arch-impressionist and posed a final challenge that he felt he had to meet head-on. It was a challenge that was made all the more pressing by the fact that those more recent movements had clearly departed from the central core of Monet's aesthetic, namely an intimate dialogue with nature. That Monet became so obsessed with his garden pictures and the idea of creating a grand decoration, therefore, is wholly logical. It would be the ultimate testimony to the powers of nature, his nineteenth-century legacy to the troubled times that followed.

As the guns of August exploded in 1914, however, the whole project almost inescapably became more political. "Many of my family have left," he told Geffroy one month after war was declared. "A mad panic has possessed this whole area. . . . As for me, I'll stay here all the same, and if these savages must kill me it will be in the midst of my canvases, in front of my life's work."[13] His letters are filled with similar defensive remarks and with pained references to the "appalling conflict," as he described the war in January 1917. In 1916 he even admitted to a friend that he was happy he had not gone to a "Kraut doctor," as he may have blinded him![14] As an expression of his patriotism, Monet signed on as a sponsor of a book published in 1915 entitled *Les Allemands, déstructeurs des cathédrales et des trésors du passé*. He also accepted a commission to paint

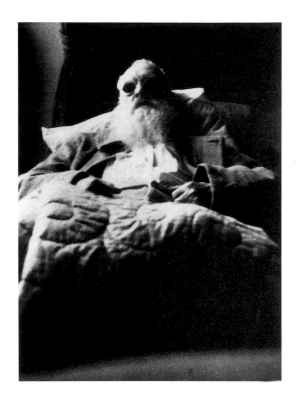

the destroyed cathedral of Reims (although he never actually executed the picture). His greatest gesture of support for his nation, however, came the day after the armistice in 1918, when he wrote a letter to his old friend Georges Clemenceau, asking him to come to Giverny. "I am on the eve of finishing two decorative panels," he told the French premier, "which I wish to sign on the day of Victory, and am asking you to offer them to the State. . . . [I]t's not much, but it's the only way I have of taking part in the victory."[15]

This gesture soon grew from a modest two pictures to an overwhelming twenty-two as the gray-haired man of state plotted with his bearded artist-friend to realize what eventually became Monet's greatest triumph—the vast series of views of his water garden spread over the curving walls of two huge oval rooms in the basement of the Orangerie on the northeast corner of the Tuileries Garden (fig. 17). This massive project, which was to enjoy the subvention of the French government, did not receive final approval until several years after Clemenceau's visit, but Monet did not wait for the official papers to be signed. He marched ahead and began to lay out the rooms as he envisioned them. It would take more than eight years to realize his dream. Between eye problems and loneliness, fits of anger and bouts of disillusionment, Monet was responsible for much of the delay himself. At several points he even threatened to abandon the whole thing. Clemenceau would have none of his whimpering. "I don't care how old you are, and whether you are an artist or not," he told Monet in 1924. "You have no right to break your word of honor, especially when it was given to France."[16]

Vacillating between fear and frustration, hope and resignation, Monet doggedly attempted to meet his obligations and complete the pictures. There were months at a time, however, that he could not or would not work, leading many to believe, himself included, that he might not be able to hold up his end of the bargain. By the winter of 1925–1926, when his health began to fail because of respiratory difficulties, he decided he would not exhibit the panels in his lifetime, a wish Clemenceau apparently agreed to respect as the last example of what he called the artist's "likable self-distrust." When Monet died in early December 1926, Clemenceau was at his side; the paintings stood where Monet had left them—in the hallowed space of his studio. Over the next two months, they were transported to Paris and ultimately installed in the two rooms that had been so inspirationally conceived and so meticulously prepared.[17]

Few people attended the inauguration ceremonies in May 1927; fewer still came to visit over the following weeks. But history can be as forgiving as it is fortuitous. Today, that special space is rightfully a kind of mecca, where people from all nations can be reminded of their essential ties to nature while being transported to realms of aesthetic reverie. As an artistic environment, it is the quintessential example of painting's powers; as the product of one man's unrelenting struggle, it is eloquent testimony to the endurance of the human spirit. Like Monet's work as a whole, it could not be a more welcome haven for us of the late twentieth century or a more fitting legacy for those who follow.

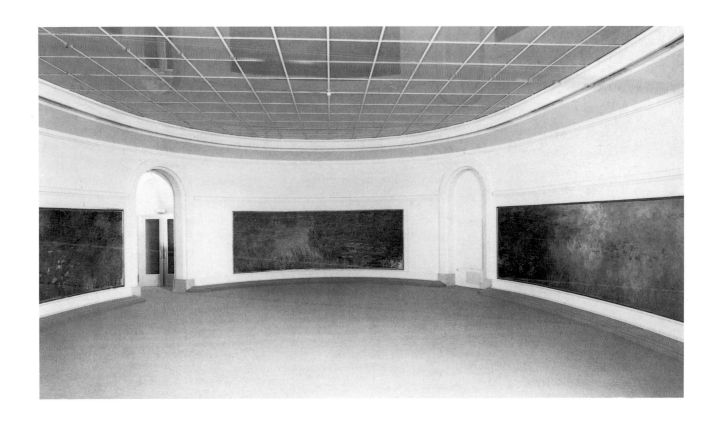

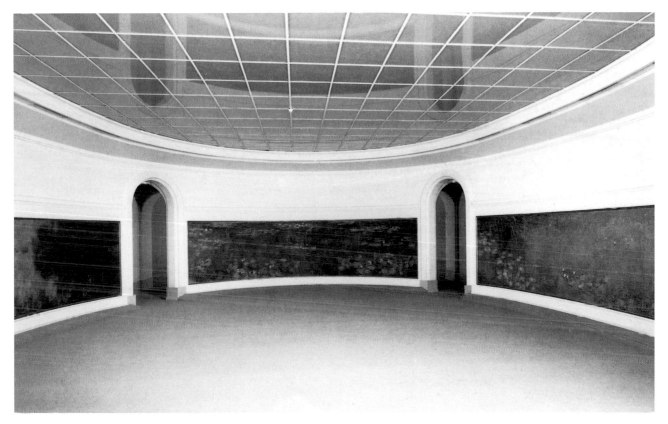

Portions of this essay appeared previously in Paul Hayes Tucker, "Of Sites and Subjects and Meaning in Monet's Art," in *Monet: A Retrospective*, exh. cat. (Tokyo: Bridgestone Museum of Art; Nagoya City Art Museum; Hiroshima Museum of Art, 1994).

1. Monet, letter of 17 March 1893 to departmental prefect as cited in Daniel Wildenstein, *Claude Monet: Biographie et catalogue raisonné*, 5 vols. (Lausanne-Paris: La Bibliothèque des Arts, 1974–1991), 3:271, w. 1191. Wildenstein's monumental work (hereafter cited as W.) is the most comprehensive study of Monet's life and a touchstone for all modern writings on the artist. Monet's letters as compiled by Wildenstein and found at the end of each volume are referred to as w. Specific studies of Monet's gardens include Robert Gordon, "The Lily Pond at Giverny: The Changing Inspiration," *The Connoisseur* 184, no. 741 (November 1973): 154–165; Robert Gordon and Charles Stuckey, "Blossoms and Blunders: Monet and the State, I," *Art in America* 67, no. 1 (January–February 1979): 102–117; Charles Stuckey, "Blossoms and Blunders: Monet and the State, II," *Art in America* 67, no. 5 (September 1979): 109–125; Kirk Varnedoe, "In Monet's Gardens," *The New York Times Magazine*, 2 April 1978, 30–41; John House, "Monet: Le Jardin d'eau et la 2ᵉ série des *Nymphéas* (1903–9)," in Jacqueline Guillaud and Maurice Guillaud, *Claude Monet au temps de Giverny* (Paris: Centre Culturel du Marais, 1983), 152–158; Claire Joyes et al., *Monet at Giverny* (London: Mathews Miller Dunbar, 1975); Michel Hoog, *Les Nymphéas de Claude Monet au Musée de l'Orangerie* (Paris: Editions de la Réunion des musées nationaux, 1987); and Daniel Wildenstein, "Monet's Giverny," in *Monet's Years at Giverny*, exh. cat. (New York: The Metropolitan Museum of Art, 1978).

2. Monet, letter of 20 March 1893 to Alice Hoschedé, as cited in W., 3:271, w. 1193.

3. [Duc de Trévise,] "Le Pèlerinage à Giverny," *La Revue de l'art ancien et moderne* 52 (July 1927): 41–52, as translated in Charles F. Stuckey, ed., *Monet: A Retrospective* (New York: Hugh Lauter Levin Associates, 1985), 320. Monet made a number of comments along these same lines, telling one interviewer, for example, that gardening and painting were the only two things that were important to him. See H. Bang, "Feuille de mon journal—Claude Monet," 6 March 1895, translated from the Norwegian in Jean-Pierre Hoschedé, *Claude Monet, ce mal connu* (Geneva: Pierre Cailler, 1960), 2:111–115; also see Maurice Kahn, "Le Jardin de Claude Monet," *Le Temps*, 7 June 1904, translated in Stuckey, *Monet: A Retrospective*, 245.

4. Joyes, *Monet at Giverny*, 37.

5. Raymond Bouyer (under the pseudonym L'Angèle), "Lettre de L'Angèle. Chronique du mois: L'impressionnisme: Corot-Monet, etc.," *L'Ermitage* 10 (May 1899): 390–400; Georges Lecomte, "Petites Expositions: Exposition Claude Monet," *Revue populaire des beaux-arts*, no. 58 (25 June 1898): 58–60; Camille Mauclair, "Choses d'art," *Mercure de France*, n.s. 14 (June 1895): 357–359. For more on these series paintings see Paul Hayes Tucker, *Monet in the '90s: The Series Paintings*, exh. cat. (Boston: Museum of Fine Arts, 1989).

6. Bouyer, "Lettre de L'Angèle."

7. For a fuller discussion of this see Tucker, *Monet in the '90s*, 252–256. On the affair, see Jean-Denis Bredin, *The Affair: The Case of Alfred Dreyfus* (New York: Georges Braziller, 1986); Norman L. Kleebatt, ed., *The Dreyfus Affair: Art, Truth, and Justice* (Berkeley: University of California Press, 1988); Patrice Boussel, *L'Affaire Dreyfus et la presse* (Paris, 1960); and John Grand-Carteret, *L'Affaire Dreyfus et l'image* (Paris, n.d.).

8. Monet, letters to Zola of 3 December 1897, 14 January 1898, and 24 February 1898, as cited in W., 3:296, w. 1397, 1399, 1402. Monet, letter of 15 February 1898 to Gustave Geffroy, as cited in W., 3:296, w. 1401. Monet expressed his concern in two other letters to Geffroy of 14 and 25 February 1898. The latter is cited in W., 3:296, w. 1403; the former is in the collection of the Stanford University Museum of Art.

9. Pissarro, letter to Lucien of 14 February 1898, cited and translated in John Rewald, ed., *Camille Pissarro: Letters to His Son Lucien*, 4th ed. (London: Routledge & Kegan Paul, 1980), 321–322.

10. Roger Marx, "Les 'Nymphéas' de M. Claude Monet," *Gazette des beaux-arts*, 4th ser., 1 (June 1909): 523–532.

11. Monet, letter of 1 December 1914 to Gustave Geffroy, as cited in W., 4:391, w. 2135. On work as "the great consoler," see Monet, letter of 29 June 1914 to Durand-Ruel, as cited in W., 4:390, w. 2123.

12. Maurice Guillemot, "Claude Monet," *La Revue illustré* 13 (15 March 1898): n.p.

13. Monet, letter of 1 September 1914 to Gustave Geffroy and letter of 9 October 1914 to Durand-Ruel, as cited in W., 4:391, w. 2128 and 2129.

14. On "Kraut doctor," see Monet, letter of 1 May 1916 to R. Koechlin, as cited in W., 4:394, w. 2180. On comments about war, see Monet, letter of 25 January 1917 to Gustave Geffroy, as cited in W., 4:935, w. 2210.

15. Monet, letter of 12 November 1918 to Georges Clemenceau, as cited in W., 4:401, w. 2287.

16. Clemenceau, letter to Monet, as cited and translated in Wildenstein, "Monet's Giverny," 36, and in Stuckey, "Blossoms and Blunders, II," 120.

17. On the lengthy evolution of the project, see Stuckey, "Blossoms and Blunders, II," 109–125.

Monet as a Garden Artist

Elizabeth Murray

[T]he garden is the man. Here is a painter who, in our own time, has multiplied the harmonies of color, has gone as far as one person can into the subtlety, opulence, and resonance of color. He has dared to create effects so true-to-life as to appear unreal, but which charm us irresistibly, as does all truth revealed.

Who inspired all this? His flowers. Who was his teacher? His garden.

He owes it a great debt, he is proud of it, and freely introduces passersby to his mentor. Such is the lesson that a plot of earth, artfully sown, can teach. Such is the light that a mere hour's visit can shed on a man's character and career.

—Arsène Alexandre, "Monet's Garden," *Le Figaro*, 9 August 1901

Claude Monet approached both gardening and painting with the same unbridled intensity and passion for color, light, and harmony. When we look at Monet's paintings, we are immediately impressed by the intimate relationship between the garden and the artist, as the garden he created became the subject of many of his paintings. Through these works and many period photographs, we have come to recognize the Grande Allée (fig. 1), the flower tunnel created with great arches of rambling roses and the broad walk carpeted with creeping, round-leafed nasturtiums, and Monet's beloved two-acre water-lily garden with the humped green bridge woven with wisteria. We know these subjects well from Monet's paintings, brilliant depictions of nature's moments of full bloom, glorious color, and light preserved on canvas through the hand of a great master.

Monet had been a passionate gardener even before his auspicious move to Giverny, where his passion and skills as both gardener and painter flourished. Since taking the first house at Argenteuil, he had surrounded himself with beautiful gardens (fig. 2). He once credited to flowers his having become a painter: "I have no other wish than to mingle more closely with nature, and I aspire to no other destiny than to work and live in harmony with her laws, as Goethe prescribed. Nature is greatness, power, and immortality; compared with her, a creature is nothing but a miserable atom."[1] He subscribed to horticultural publications and collected many books on gardening. He often consulted his twenty-six-volume set of *Flore des serres et des jardins de l'Europe* (*Flowers of the Greenhouses and Gardens of Europe* [Ghent: Louis Van Houtte, 1845]), which

OPPOSITE: Detail from *Water Lilies and Agapanthas*, cat. no. 5

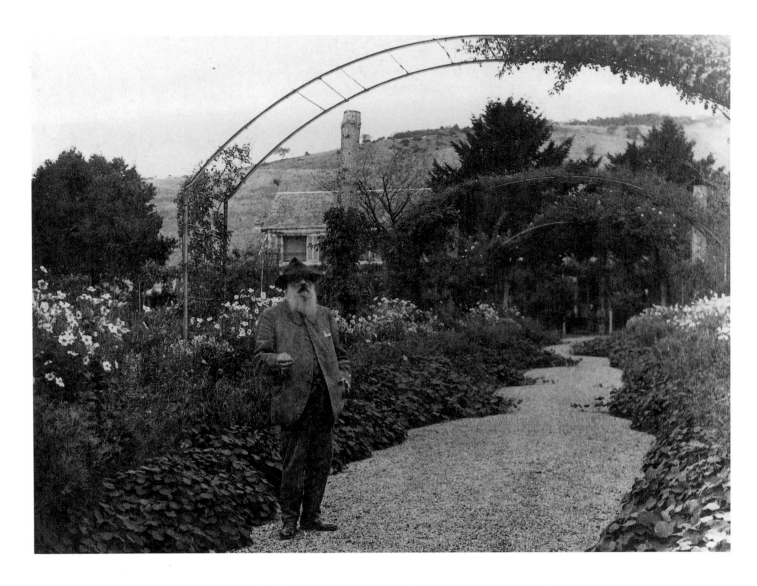

FIG. I
Claude Monet in his garden, ca. 1923
Photograph
Musée Claude Monet, Giverny

had beautiful color plates and was still considered the best reference source even at the end of the century.

In 1883 when Monet, Alice Hoschedé, and their combined eight children arrived in Giverny, they found a pink stucco house to lease which comfortably accommodated their large family. Finally, here was a place surrounded by a charming landscape, hills, flowering meadows, creeks leading to the Seine River, and marvelous light, where Monet could really settle in and paint. The only essential work that had to be done immediately was to redo the garden. Flowers had to be planted for cut arrangements for Monet to paint on rainy days when he could not be outside. Vegetables were also important to feed everyone, and at first these were planted in their own area of the garden. Later, when Monet had more funds, he bought the Blue House in the middle of the village, where all the vegetables and herbs for his gourmet meals were grown. This was done so that he could devote his entire garden to the flowers he so loved.

Monet committed himself fully to his garden—he planned, planted, and weeded the garden, and in the evening the children watered it, hauling buckets from the well. Monet planted a wide range of annuals, perennials, bulbs, and vines, so that there were

continuous displays of color throughout the seasons. The old fruit orchard, overburdened with clipped box-wood that gave it the appearance of a formal, stuffy garden, was gradually transformed. Monet and Alice agreed that the boxwood should be removed immediately. Many of the fruit trees gave way to ornamental flowering trees, like the crab apples and all sorts of roses and clema-tis on arbors, trellises, and arches (fig. 3). These structures gave the garden an architectural element, as well as carry-ing color up into the sky. The spruce and cypress trees, however, were a source of contention for twenty years. The spruces remain today at the head of the Grande Allée and the cypresses went.

It was not for seven years, in 1890, that Monet was able to buy the Pink House he and his family loved so well. By then the gardens were becoming so profuse and time-consuming that Monet could no longer keep them up himself—with only the help of his children—without his painting suffering. In 1892 he hired Félix Breuil to be the head gardener, who was subsequently joined by five other gardeners. Monet remained in charge of all design and selection of plants and seeds. He would continue to take his daily strolls through the garden for inspiration and meditation, as well as to inspect the plantings. Absolute neatness was essential to him, and the garden-ers spent a great deal of time deadheading spent flowers and raking leaves. If Monet noticed a clashing color scheme or saw where a vista needed opening, he immedi-ately directed his gardeners to transplant or prune some-thing to his discerning eye's specifications. Occasionally the head gardener would plead with Monet not to plant so many flowers, arguing that the plants needed more room. Monet, a skilled horticulturist himself, countered Breuil's objections by improving the chalky soils with compost so the soil could support his artistic color har-monies. "The garden is not the luxury hobby of some property owner, created to show off the quality of his seeds; it is the retreat of an artist, and the flowers are his companions. He wants to be able to caress them as he goes by, to feel them close to him, surrounding him, friendly and beneficent parts of his life."[2]

That Monet was in love with his garden is no exaggeration. Like most gardeners, he would spend hours poring over plant and seed catalogues, featuring specimens from around the world, and never tired of talking with close friends about gardening. Gustave

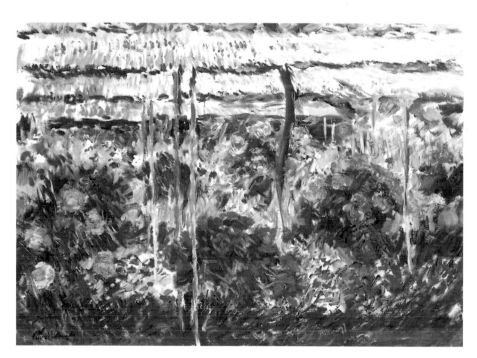

FIG. 2
Pierre-Auguste Renoir
Monet Painting in His Garden at Argenteuil, 1873
Oil on canvas, 19¾ x 42 in. (50.2 x 106.7 cm)
Wadsworth Atheneum, Hartford. Bequest of Anne Parrish Titzell

FIG. 3
Peonies, 1887
Oil on canvas, 28¾ x 39⅜ in. (73 x 100 cm)
Private collection, Switzerland. Courtesy Galerie Beyeler, Basel

THE FLOWER GARDEN

1. Wall with rose trees and espaliered pear trees.
2. Monet's second studio.
3. Orchard greenhouse.
4. Cold frames for seedlings.
5. Growing plots for new plants.
6. Entrance to underground passage to
 water garden.
7. Linden trees.
8. Apple, plum, and cherry trees with
 wallflowers beneath.
9. Lilac trees.
10. Cherry trees.
11. Shrub and pillar roses on 10-ft. columns.
12. Iris and rose perennial border.
13. Tamarix tree.
14. Island bed with rose trees, cottage pinks, and
 tulips with forget-me-nots.
15. Pillar roses with monochromatic flowers.
16. Lawn with plantings of iris and
 oriental poppies.
17. Monet's house.
18. Spruce trees.
19. The Grande Allée (172 x 22 ft.).
20. Gate opening onto the chemin du Roy.
21. Japanese flowering crab apple trees
 with yellow wallflowers beneath in spring.
22. Flower beds (each 6 x 13 ft.).
23. Flower beds topped by clematis arbors.
24. White turkey yard.
25. Lawn surrounded by espaliered apple trees.
26. Monochrome perennial beds.
27. Smoke tree.
28. Perennial beds.
29. Standard roses.
30. Modern entrance for visitors.
31. Monet's third studio.
32. Chicken yard.
33. Gardener's cottage.
34. Espaliered apple trees.
35. Pine tree.
36. Green benches.
37. Visitors' path.

The flower garden at Giverny
(designed by Elizabeth Murray,
illustrated by Heather O'Connor)
Garden dimensions, 380 x 240 ft.

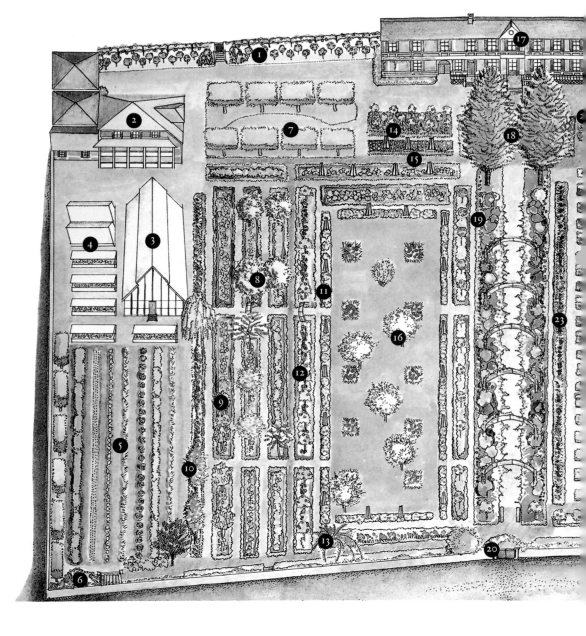

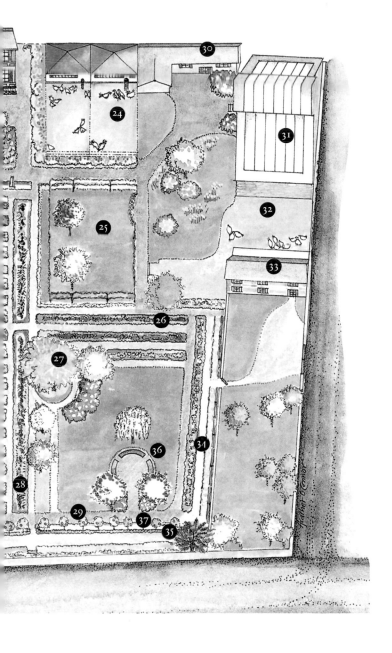

THE WATER GARDEN

1. Entrance to underground passage to flower garden.
2. Footbridge over the stream called the Ru.
3. Bamboo grove.
4. Pond sluice.
5. Gate to the flower garden.
6. Japanese footbridge (18-ft. span) with wisteria arbor.
7. Round stone benches.
8. Copper beech tree.
9. Footbridge with rose arch.
10. Weeping willow.
11. Island of yellow water irises (12 x 12 ft.).
12. Water lilies.
13. Azaleas.
14. Boat dock and rose arches.
15. Footbridge.
16. Wisteria arbor (6 ft. high; 34½ ft. long).
17. Footbridge over fresh water sluice.
18. Japanese cherry tree.
19. Weeping willow.
20. Footbridge.

The water garden at Giverny
(designed by Elizabeth Murray,
illustrated by Heather O'Connor)
Garden dimensions 418 x 153 ft.

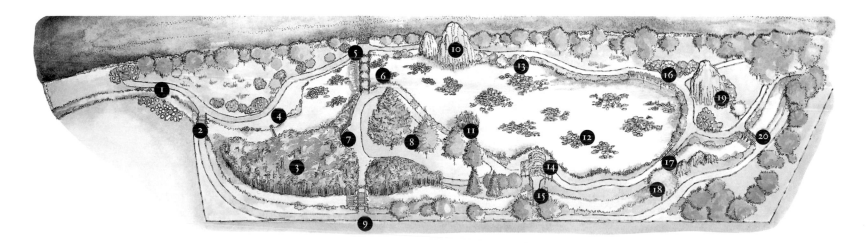

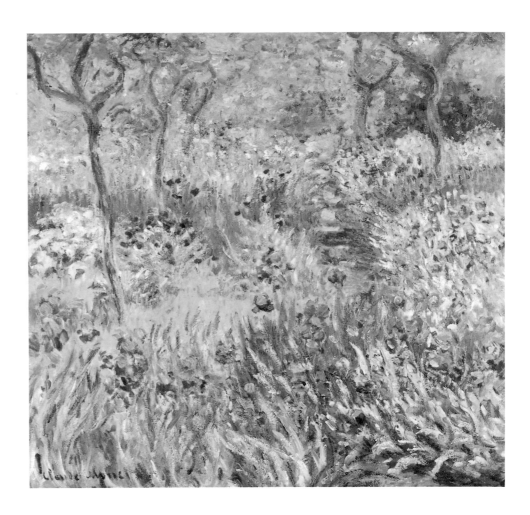

Caillebotte and Octave Mirbeau were among those who enjoyed boating with Monet as well as exchanging ideas about gardening. Mirbeau is quoted as having said in a letter to Monet:

> *I'm very glad that you're bringing Caillebotte. We'll talk gardening, as you say, because as for art and literature, it's all humbug. There's nothing but the earth. As for me, I've reached the point of finding a lump of soil marvelous, and I spend whole hours contemplating it. And humus! I love humus the way one loves a woman. I smear it on myself, and in the fuming heaps I see the beautiful forms and beautiful colors that will be born from it! How little art is next to that! And how simpering and false.*[3]

As with his painting, Monet was very disciplined yet experimental with his garden. He loved to try new plants but grew them to the side of the main garden, near the greenhouse and cold frames. He carefully checked their color of bloom and hardiness before the new plants were planted en masse in the main garden. Because he preferred to plant in large color blocks, he would not depend on a catalogue description alone.

At the time Monet started painting, most artists began their training by drawing in the studio, whether after antique casts, still-life elements, or a live model. Landscape

FIG. 5
Grande Allée
Color photograph by Elizabeth Murray

painters often sketched various views from nature and then created a pleasing composition in their studios. The plein-air impressionists painted directly from nature, out-of-doors, dedicating themselves to capturing the impression of a fleeting moment. They carried their paints, canvases, and easels through the meadows and orchards and along streams until they chanced upon an inspirational view. When they found a composition and viewpoint pleasing to them, perhaps a certain group of trees backlit with the rising sun or the reflection of a bridge or boats in a river, they set about painting it.

Monet expanded this concept of finding compositions in nature into arranging natural beauty as he designed, adjusted, and redesigned and developed his gardens. He created his own still lifes and landscapes on a grand scale with his flower garden and water-lily pond. He lived and breathed the source of his inspiration. Each flower that grows in this magnificent painter's paradise is thoughtfully placed, just as if it appeared in an exquisite flower arrangement prepared for a painter's still life. With such a trained eye for color relationships and the effects of light and atmosphere on color, Monet automatically employed the same principles he used to create his canvases. He carefully arranged pure colors in the abstract form of flowering plants to create richly patterned textures and mood by contrasting harmonizing color relationships.

Monet was an impassioned colorist; he continually experimented with color and texture to convey the nuances of light in nature in his paintings as well as in his living canvas, his gardens at Giverny. He organized different areas of the gardens according to various color schemes. Fully understanding the complexities of color, in a sophisticated manner he sought to simplify color relationships to create a diverse, yet integrated result. In some areas he planted monochromatic masses—color zones—like the one-meter-wide flower beds of solid lavender-purple *Iris germanica* (fig. 4). In another area, monochromatic flowers would range in value from pure white to soft pink, vibrant red to shades of crimson, all placed together to create a tonal structure.

Monet did not like plants with variegated foliage in his gardens. He found them too busy and was bothered by their hybridized look. He did, however, use bicolor flowers, like burgundy cactus dahlias with gold-tipped petals and pale cream peonies tinged with pink in the center, to introduce various nuances of color in an otherwise monochromatic flower bed. Monet used these prized flowers with discretion, placing them with a deliberation equal to that required to place a brushstroke loaded with two colors. He generally preferred the simple, single-petaled flowers to the more hybridized fancy doubles. Luminosity was essential to Monet. He was a keen observer of the effects of light shining through the petals of an iris or a poppy, recalling stained-glass windows. He encouraged wild native plants into his garden, such as the wild scarlet poppies and the handsome verbascum with its downy gray-green leaves and tall flower spikes in soft yellow or purple.

FIG. 6
Wallflowers
Color photograph by Elizabeth Murray

To break uniformity and to unite the garden, Monet chose a dominant color that he would integrate throughout the whole. Sequences of small touches of blue, lavender, or gold accents would be interwoven throughout the flower scheme. Color sequences varied with each season, accentuating the changes in light and weather. The interplay of delicate to strong color contrasts keynoted the floral compositions of the walled flower garden called the Clos Normand (see plan, pp. 50–51), breaking the uniformity of the garden grid. The abundance of sprawling edging plants like aubretia, saxifrage, and nasturtium softened the straight lines of the formal layout (fig. 5). To increase the various atmospheric effects of the garden, Monet planted rich orange, pink, gold, and bronze wallflowers and tulips together on the west side to emphasize the effects of the setting sun (fig. 6). He used clear blue and delicate salmon hues elsewhere to convey the tonal effect of mist softening the morning light. Planting pastel hues in the distance that appeared visually next to bright, crisper values of the same color in the foreground added a painterly illusion of distance. With the living, growing, and changing plants, always subject to light and weather, Monet created an organized, concentrated color environment, where he could live, breathe, observe, and walk, constantly having his painter's eye challenged by the effects of light.

Monet created his water-lily garden for beauty (see plan, pp. 50–51). What he found was endless inspiration and tranquility. His greatest passion and challenge was to paint the fleeting quality of the light. In his water garden he discovered infinite motifs. The pond was a mirror reflecting each nuance of atmospheric change— a moving cloud, a ripple of wind, a coming storm (fig. 7). It held inverted images of the surrounding landscape while simultaneously supporting thousands of floating water flowers. The effect was that of a prism in the light, spreading shimmering shades of precious gold, ruby, amethyst, sapphire, and topaz over the surface of the water. These flowers (fig. 8) were like multifaceted jewels on deep green settings of round, floating, palette-shaped leaves. The pond thus became a focal point for Monet, which he treated with reverence, as a personal sanctuary.

Monet would become completely engrossed with the pond, recording the effects of the ever-changing light. He saw to it that his pond was well cared for. The flowering surface was maintained by one gardener who spent his entire day tending it. His first assignment began before dawn, when the master would come to set up his canvases to catch the first light. The water gardener would row out in the pond in a small green flat-bottomed boat to clean the entire surface. Any moss, algae, or water grasses which grew from the bottom had to be pulled out. Monet insisted on clarity. Next the gardener would inspect the water lilies themselves. Any yellow leaves or spent blossoms were removed. If the plants had become dusty from vehicles passing by on the chemin du Roy, the dirt road nearby, the gardener would take a bucket of water and rinse off the leaves and flowers, ensuring that the true colors and beauty would shine forth. Later this job was less necessary, as Monet paid the municipality to pave the chemin du Roy, so as to avoid the dust on his precious flowers.

The water lilies had to be fed rich fertilizer to bloom at their best, so the gardener devised ways to poke the food, wrapped in a cloth like a tea bag, into the muddy roots so as not to disturb the water. The gardener was also instructed to keep the floating pads of the water lilies in informal circular patterns with the water surface clear between each lily plant. Monet issued explicit instructions that the rampantly growing plants not be allowed to touch one another and thus obscure too much of the water's surface (fig. 9). For the surface gave Monet his surprise gifts of sky and inverted landscape. It was an

FIG. 7
The water-lily pond in winter
Color photograph by Elizabeth Murray

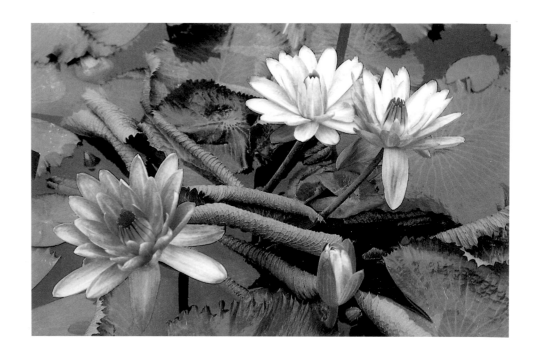

FIG. 8
Water lilies
Color photograph by Elizabeth Murray

FIG. 9
The water-lily pond
Color photograph by Elizabeth Murray

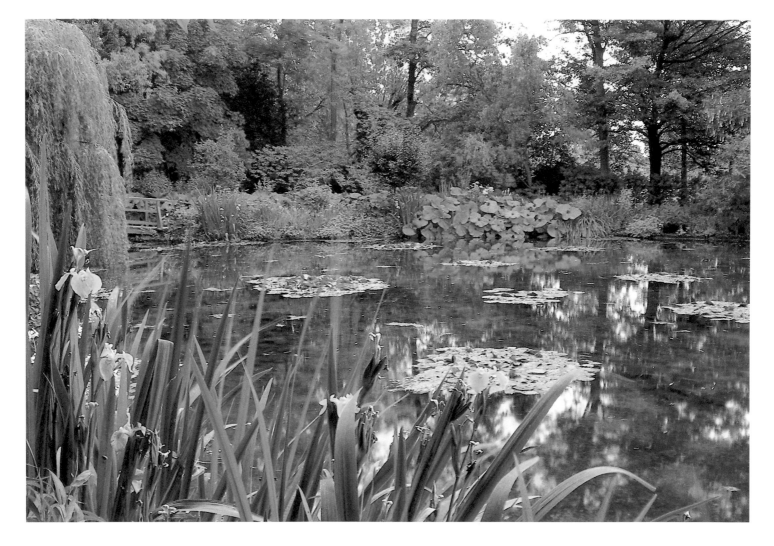

essential part of the overall design. The landscape edges of the pond were kept relatively simple so as not to compete with the flowering water. Blue and white spheres of agapanthus bloomed in the summer after the abundant Japanese and Siberian irises. The beloved iris flowered profusely in late April and May at the water's edge, providing elegant spikes of blue and violet. The Kurokis, Monet's Japanese collector friends, who visited several times from Japan to buy his work, often sent the artist rare peony shrubs and lily bulbs, species that were completely unknown in France. Japanese tree peonies as well as herbaceous peonies with colors ranging from white and yellow to deep pinks and burgundy reds provided warm tones toward the end of May, when the daylilies would take over with their rich earthy colors.

Monet's great admiration of the Japanese aesthetic was seen not only in his vast collection of Japanese woodblock prints, one of which inspired the design of his humpback bridge, but in many of the plants he chose for his gardens. The water garden especially was an ideal environment for Japanese plants. The flowering trees were Japanese crab apple and Japanese plum trees, whose delicate pink and white blossoms floated above the flowering azaleas and rhododendrons, creating a bridal-like lace against the new spring green leaves of the weeping willow trees and golden laburnum (Golden Rain Tree). The foot of the Japanese bridge was designed to be on an axis with the Grand Allée (see plan, p. 59), which led to Monet's front door. At the other side of the bridge was a dense grove of bamboo of rare varieties, many of which are native to Japan. Among this unique botanical collection (considered the best in France) was black bamboo with its dark stems and green leaves. Monet cut inviting vistas through these twenty-five-foot-high specimens, taking advantage of the intriguing play of light they made.

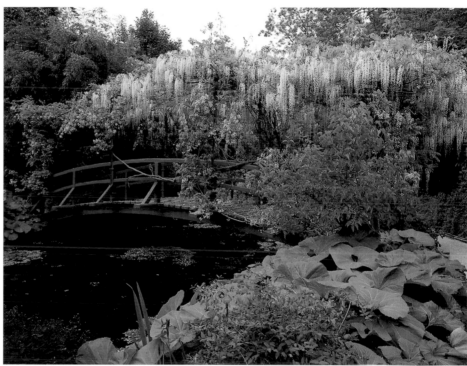

FIG. 10
The bridge in bloom
Color photograph by Elizabeth Murray

Eighteen years after Monet made his water garden he enlarged it for a second time and added the wisteria arbor to the bridge (fig. 10). Monet combined Japanese and Chinese strains to achieve a prolonged blooming period. He planted mauve wisteria for its profusion of blooms on the upper trellis of the bridge and white on the lower spans, providing breathtaking reflections in the water below. He gave linear structure to the far side of the pond by planting a lavender wisteria on a six-foot-high, thirty-five-foot-long arbor (fig. 11), which continues to bloom there each spring.

Monet was not only inspired to paint hundreds of canvases of his beloved water garden; he also felt moved to gather his paintings up as a bouquet to present to France. His vision was to create two large oval rooms covered with panels of water lilies, which would be so large as to engage the viewer completely, to create a peaceful environment (Tucker, fig. 17). He wanted to provide a place of beauty and harmony, a refuge for his

war-torn countrymen. He visualized contemplative rooms, where visitors could enter into the center of the pond and have the extraordinary effects of light soothe and enliven their souls:

> *I was once briefly tempted to use water lilies as a sole decorative theme in a room. Along the walls, enveloping them in the singleness of its motif, this was to have created the illusion of an endless whole, of water without horizon or shore. Here nerves taut from overwork could have relaxed, lulled by the restful sight of those still waters, and to whosoever lived there, the room would have offered a refuge for peaceful meditation at the center of a flowering aquarium.*[4]

Monet's paintings of his gardens are renderings of his keen sensitivity and connectedness to nature and light. Monet's vision was all-encompassing. He embraced beauty and harmony in the natural world and was determined to communicate it in his gardens and through his paintings. His friend and contemporary Octave Mirbeau wrote:

> *This is where Claude Monet lives, in this neverending feast for the eyes. It is just the environment one would have imagined for this extraordinary painter of the living splendor of color, for this extraordinary poet of tender light and veiled shapes, for this man whose paintings breathe, are intoxicating, scented; this man who has touched the intangible, expressed the inexpressible, and whose spell over our dreams is the dream that nature so mysteriously enfolds, the dream that so mysteriously permeates the divine light.*[5]

Monet lived to complete his *Décorations des nymphéas* but not to see them installed in the Orangerie. He remained at Giverny until his death, having devoted forty-three years to his gardens. Through his complete dedication, vision, and love, Monet's gardens became a world unto their own, a vibrant, thriving source of inspiration for his paintings, as well as living works of art in their own right. These gardens today attract thousands of visitors, who are in turn filled with the master's living spirit.

NOTES

1. Monet, quoted by Roger Marx, "M. C. Monet's 'Water Lilies,'" *Gazette des beaux-arts* (June 1909), quoted in Charles F. Stuckey, ed., *Monet: A Retrospective* (New York: Hugh Lauter Levin Associates, 1985), 267.

2. Maurice Kahn, "Claude Monet's Garden," *Le Temps*, 7 June 1904, quoted in Stuckey, *Monet: A Retrospective*, 244.

3. Octave Mirbeau to Monet, quoted in Robert Gordon and Andrew Forge, *Monet* (New York: Harry N. Abrams, 1983), 221.

4. Monet, quoted by Marx, "Monet's 'Water Lilies,'" quoted in Stuckey, *Monet: A Retrospective*, 18.

5. Octave Mirbeau, "Claude Monet," *L'Art dans les deux-mondes*, 7 March 1891, quoted in Stuckey, *Monet: A Retrospective*, 159.

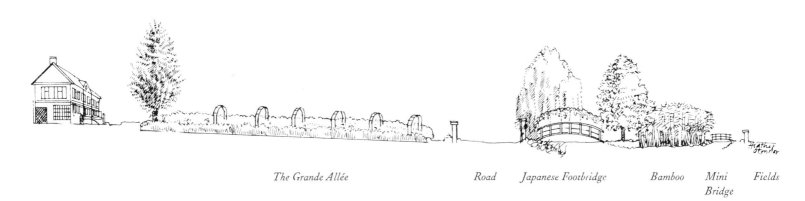

The Grande Allée Road Japanese Footbridge Bamboo Mini Fields
 Bridge

Axial view of Monet's gardens (designed by Elizabeth Murray, illustrated by Heather O'Connor)

The Exhibition

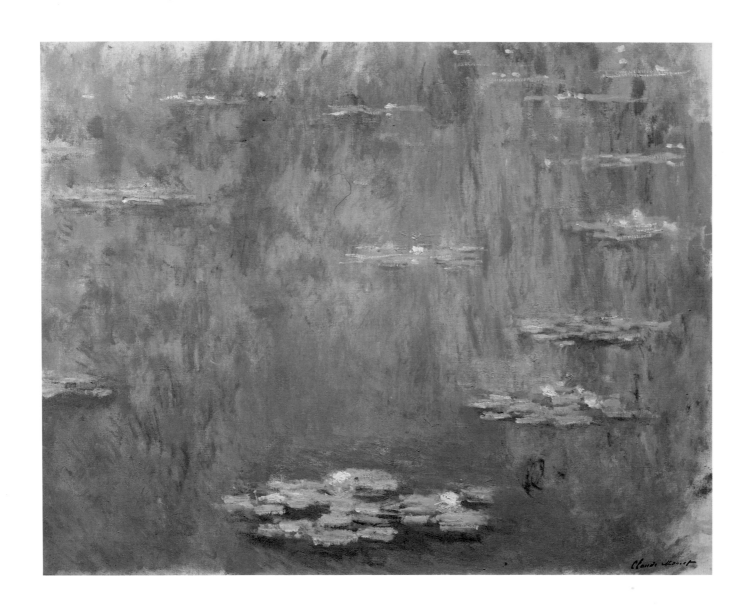

CAT. NO. 1
Water Lilies (*Nymphéas*), 1903
Oil on canvas
28¾ x 36¼ in. (73 x 92 cm)
Signed lower right with studio stamp: *Claude Monet*
Inv. no. 5163

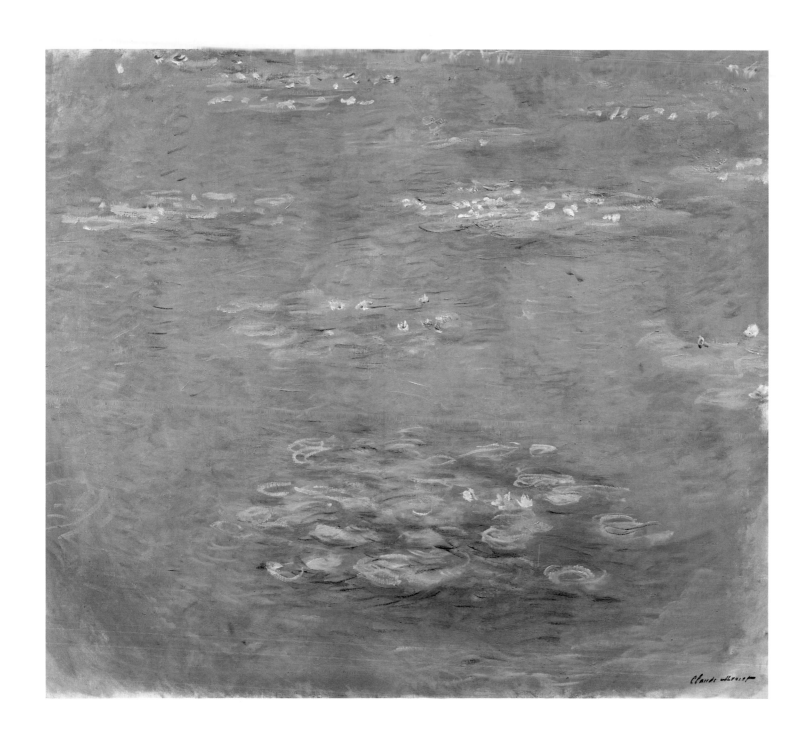

CAT. NO. 2
Water Lilies (Nymphéas), 1903
Oil on canvas
35 x 39⅜ in. (89 x 100 cm)
Signed lower right with studio stamp: *Claude Monet*
Inv. no. 5166

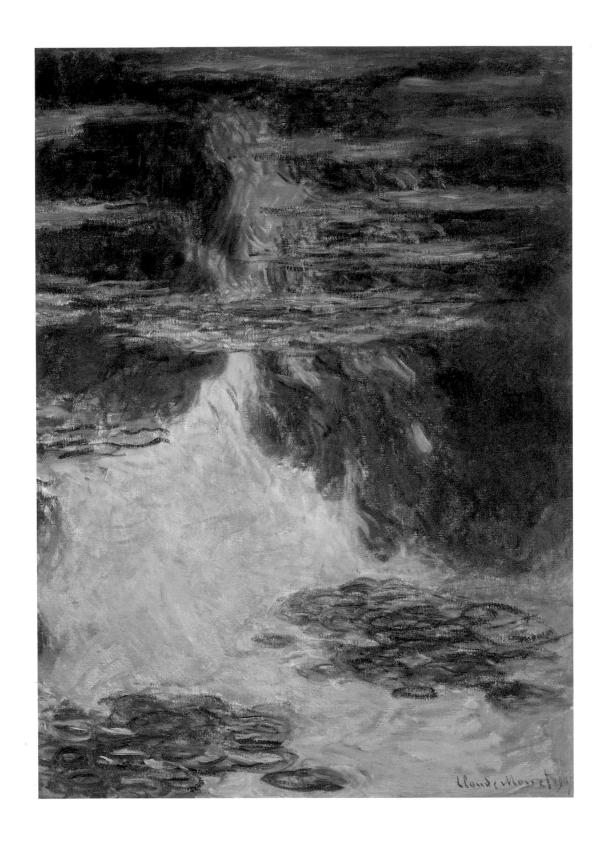

CAT. NO. 3
Water Lilies (*Nymphéas*), 1907
Oil on canvas
39⅜ x 28¾ in. (100 x 73 cm)
Signed and dated lower right: *Claude Monet 1907*
Inv. no. 5168

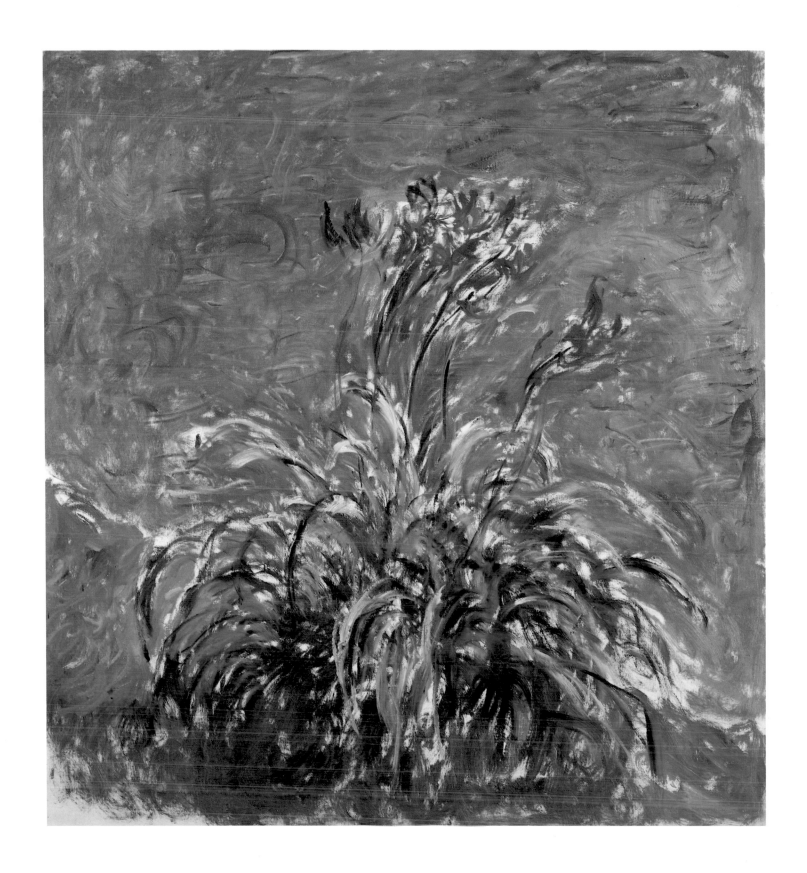

CAT. NO. 4
Daylilies (Les Hémérocalles), 1914–1917
Oil on canvas
59 x 55⅛ in. (150 x 140 cm)
Inv. no. 5097

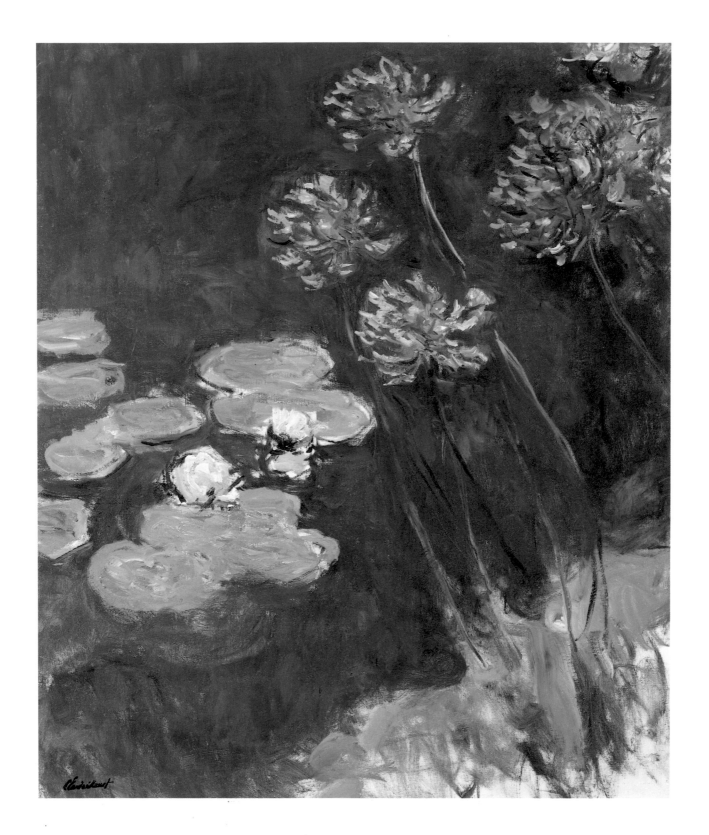

CAT. NO. 5
Water Lilies and Agapanthus
(*Nymphéas et agapanthes*), 1914–1917
Oil on canvas
55⅛ x 47¼ in. (140 x 120 cm)
Signed lower left with studio stamp: *Claude Monet*
Inv. no. 5084

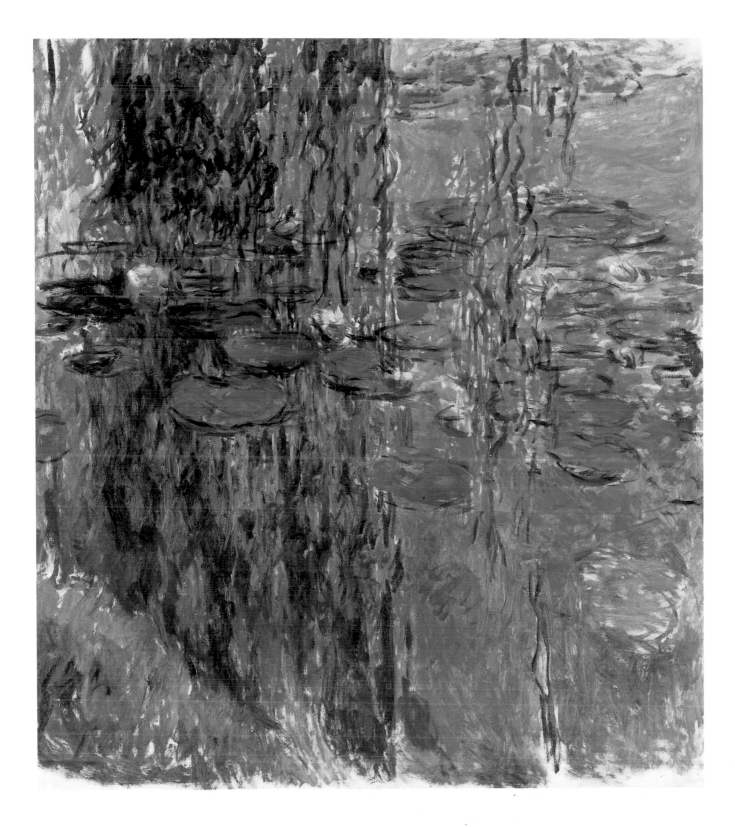

CAT. NO. 6
Water Lilies (*Nymphéas*), 1916–1919
Oil on canvas
78¾ x 70⅞ in. (200 x 180 cm)
Inv. no. 5117

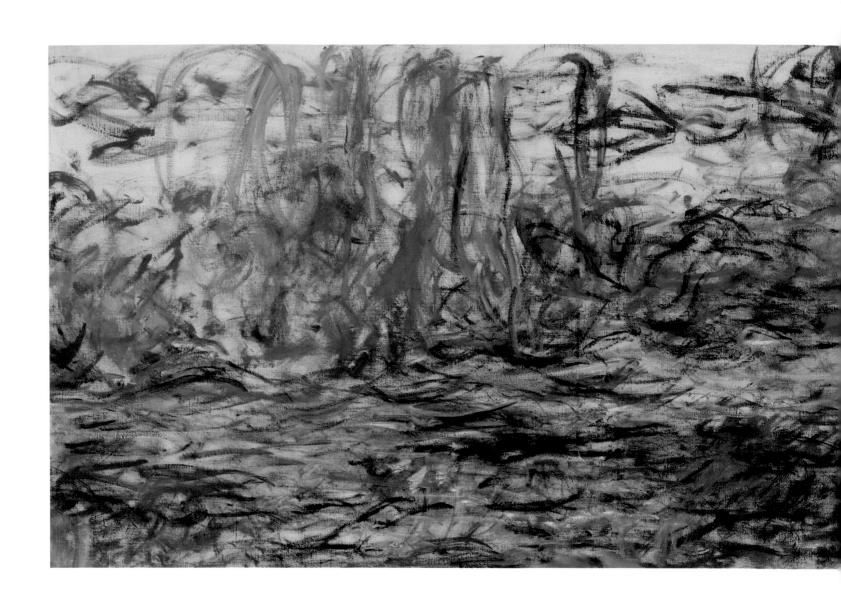

CAT. NO. 7
Water Lilies (*Nymphéas*), 1917–1919
Oil on canvas
39⅜ x 118⅛ in. (100 x 300 cm)
Inv. no. 5118

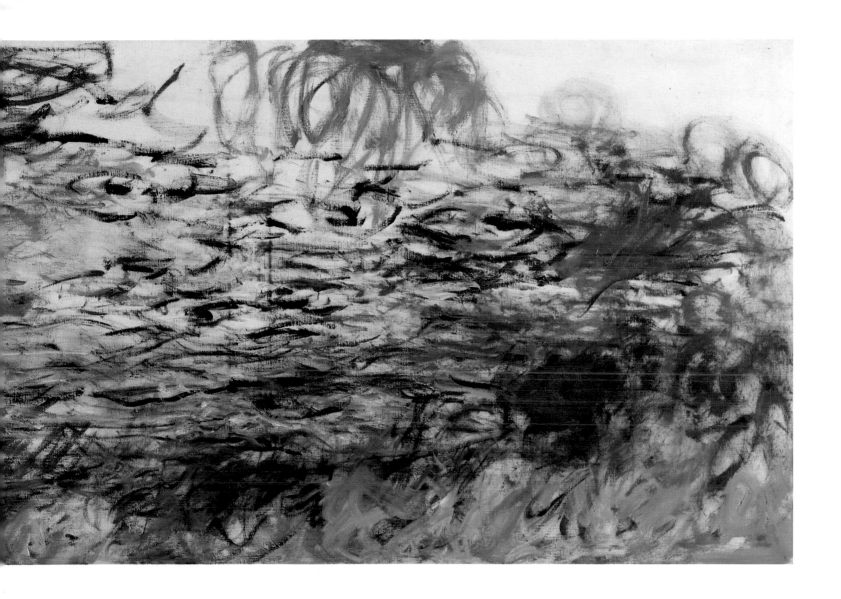

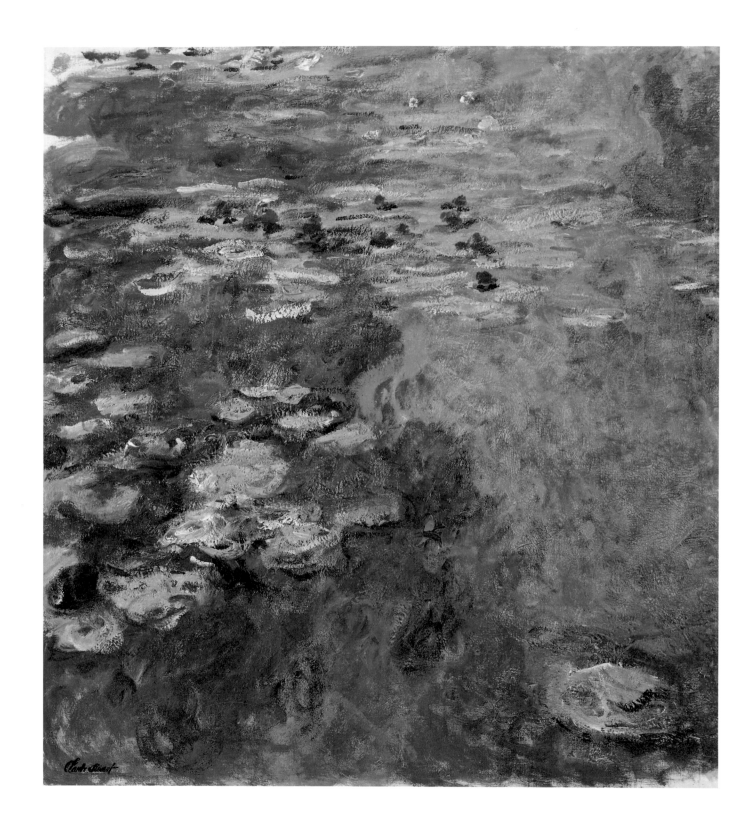

CAT. NO. 8
The Pond of Water Lilies
(*Le Bassin aux nymphéas*), 1917–1919
Oil on canvas
51⅛ x 47¼ in. (130 x 120 cm)
Signed lower left with studio stamp: *Claude Monet*
Inv. no. 5165

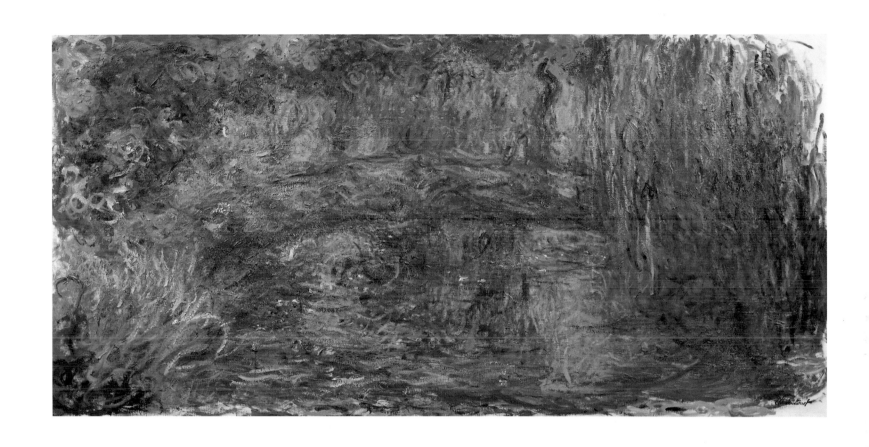

CAT. NO. 9
The Japanese Footbridge
(*Le Pont japonais*), 1918
Oil on canvas
39⅜ x 78¾ in. (100 x 200 cm)
Signed lower right with studio stamp: *Claude Monet*
Inv. no. 5077

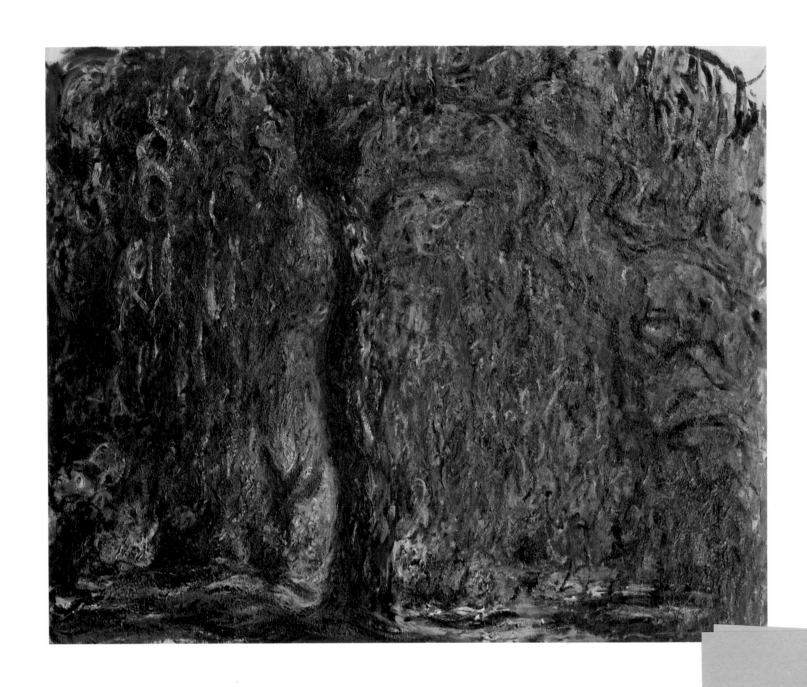

CAT. NO. 10

Weeping Willow (*Saule pleureur*), 1918–1919

Oil on canvas

39⅜ x 47¼ in. (100 x 120 cm)

Inv. no. 5080

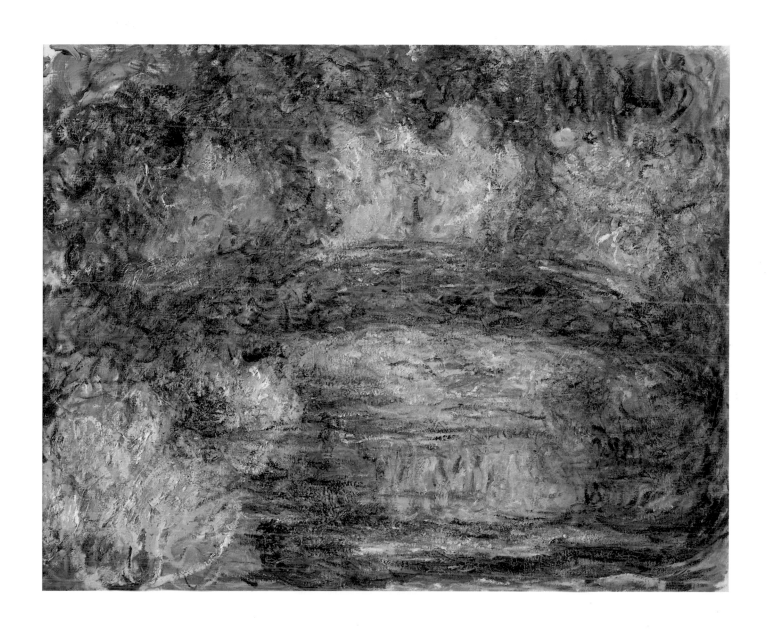

CAT. NO. 11
The Japanese Footbridge
(*Le Pont japonais*), 1918–1919
Oil on canvas
29⅛ x 36¼ in. (74 x 92 cm)
Inv. no. 5177

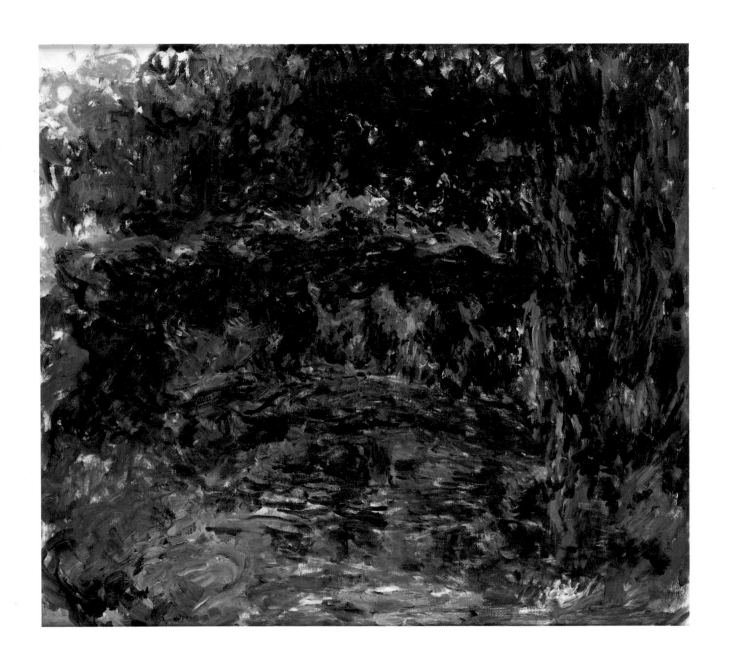

CAT. NO. 12
The Japanese Footbridge
(*Le Pont japonais*), 1918–1924
Oil on canvas
35 x 39⅜ in. (89 x 100 cm)
Inv. no. 5091

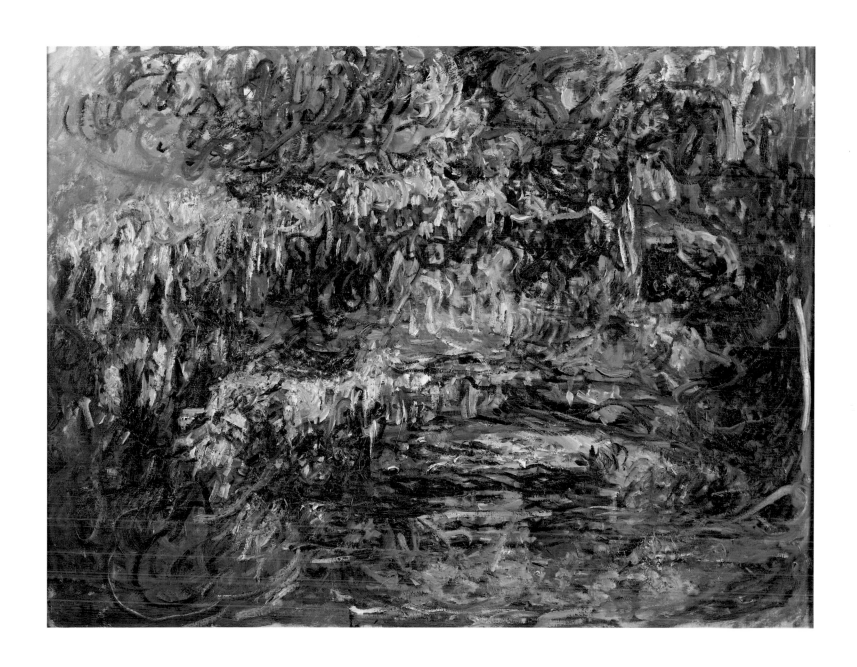

CAT. NO. 13
The Japanese Footbridge
(*Le Pont japonais*), 1918–1924
Oil on canvas
35 x 45⅜ in. (89 x 116 cm)
Inv. no. 5106

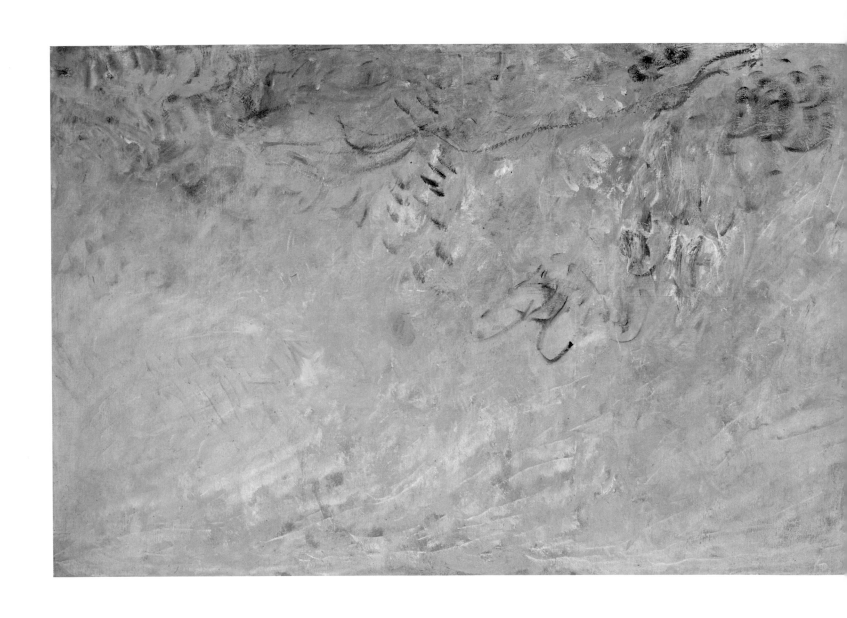

CAT. NO. 14
Wisteria (*Glycines*), 1919–1920
Oil on canvas
39⅜ x 118⅛ in. (100 x 300 cm)
Inv. no. 5123

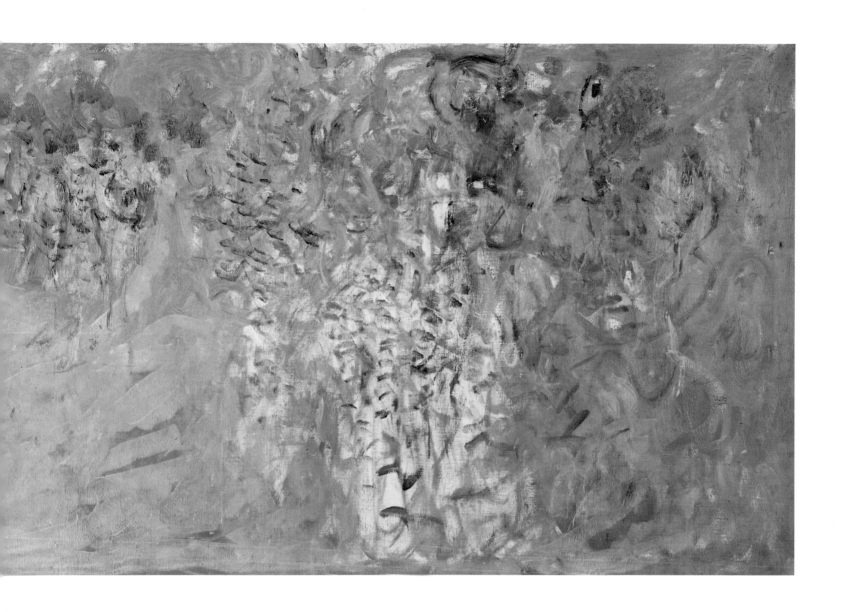

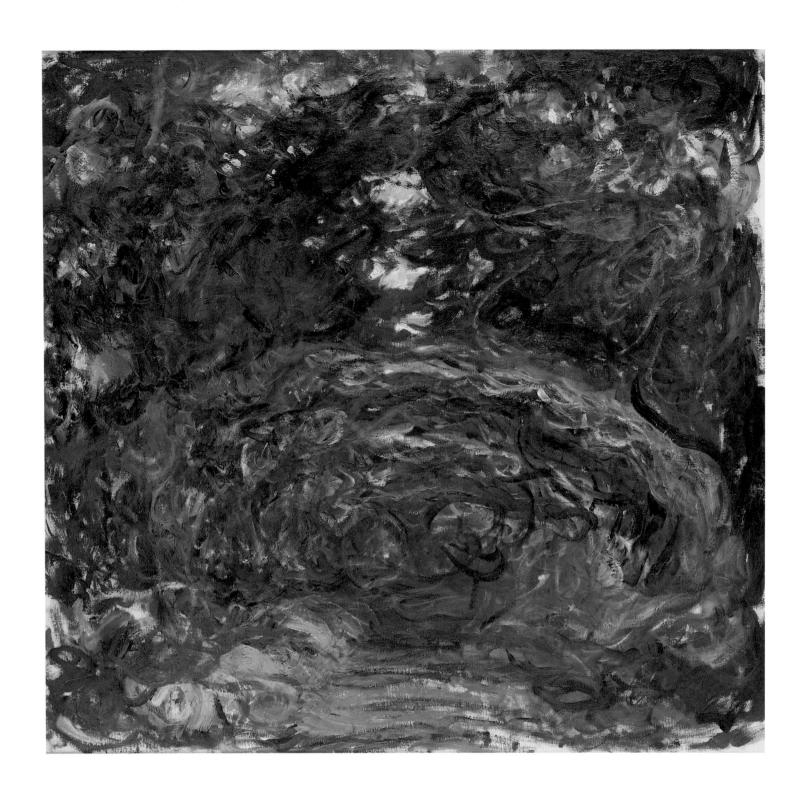

CAT. NO. 15
The Path with Rose Trellises
(*L'Allée des rosiers*), 1920–1922
Oil on canvas
35⅜ x 36¼ in. (90 x 92 cm)
Inv. no. 5088

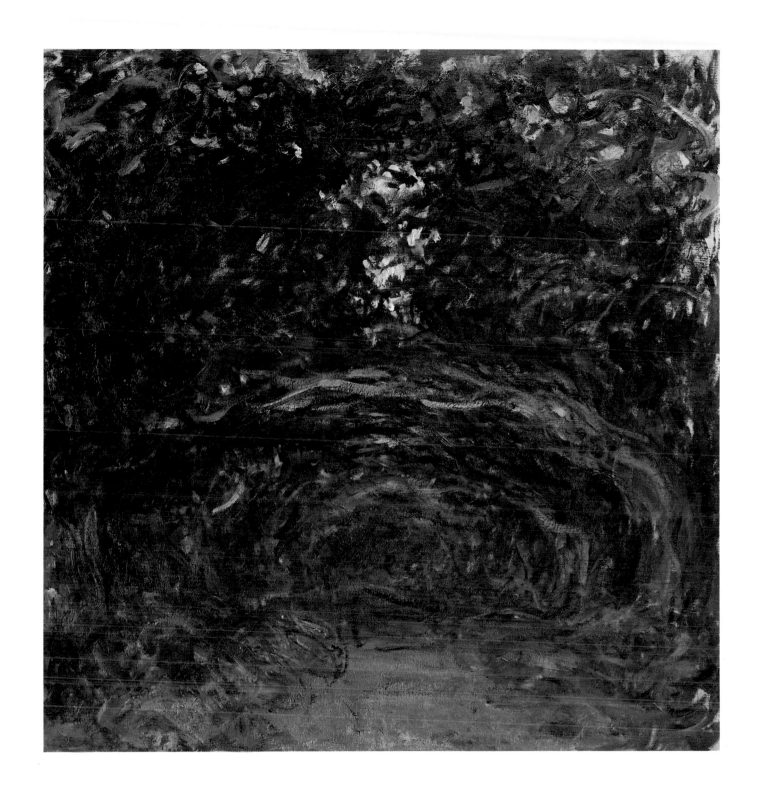

CAT. NO. 16
The Path with Rose Trellises
(*L'Allée des rosiers*), 1920–1922
Oil on canvas
36¼ x 35 in. (92 x 89 cm)
Inv. no. 5104

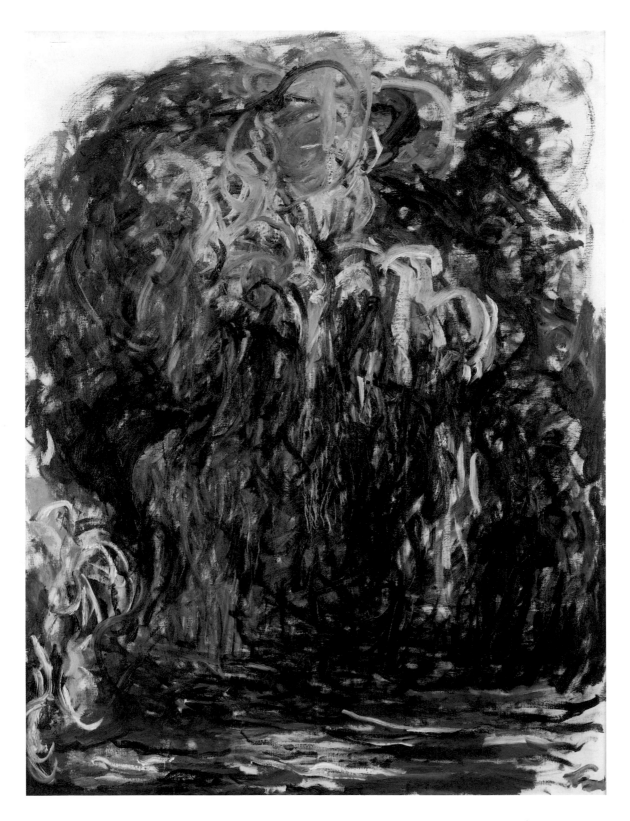

CAT. NO. 17
Weeping Willow (*Saule pleureur*), 1921–1922
Oil on canvas
45⅝ x 35 in. (116 x 89 cm)
Inv. no. 5107

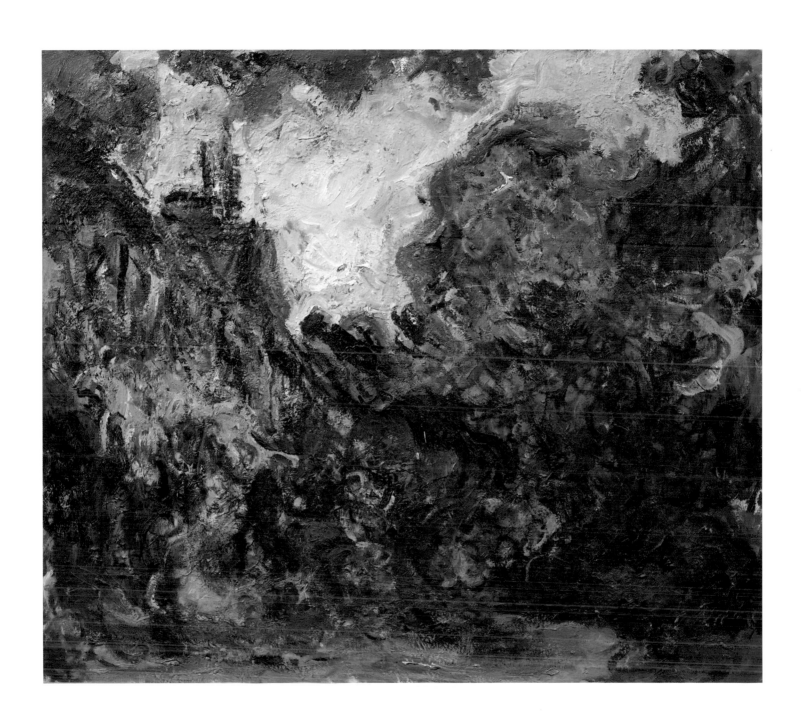

CAT. NO. 18
The House from the Rose Garden
(*La Maison vue du jardin aux roses*), 1922–1924
Oil on canvas
31⅞ x 36⅝ in. (81 x 93 cm)
Inv. no. 5087

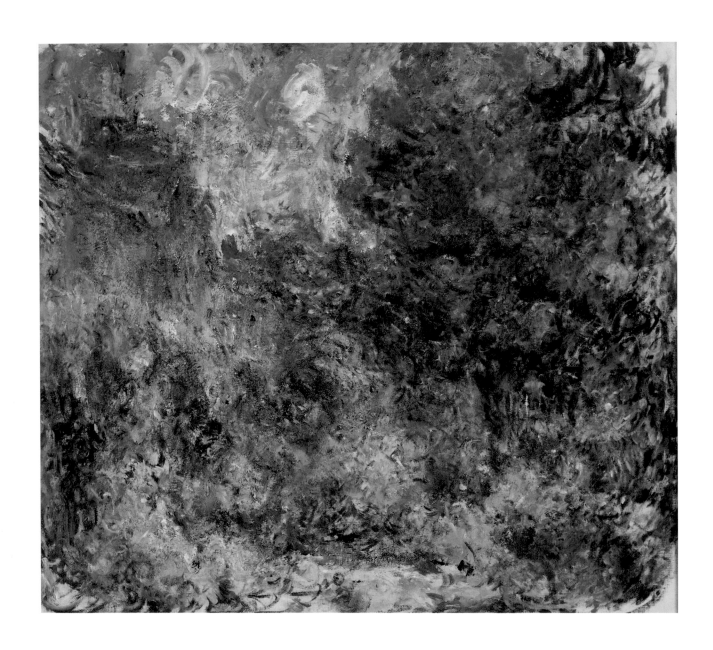

CAT. NO. 19
The House at Giverny from the Rose Garden
(*La Maison de Giverny vue du jardin aux roses*), 1922–1924
Oil on canvas
35 x 39⅜ in. (89 x 100 cm)
Inv. no. 5103

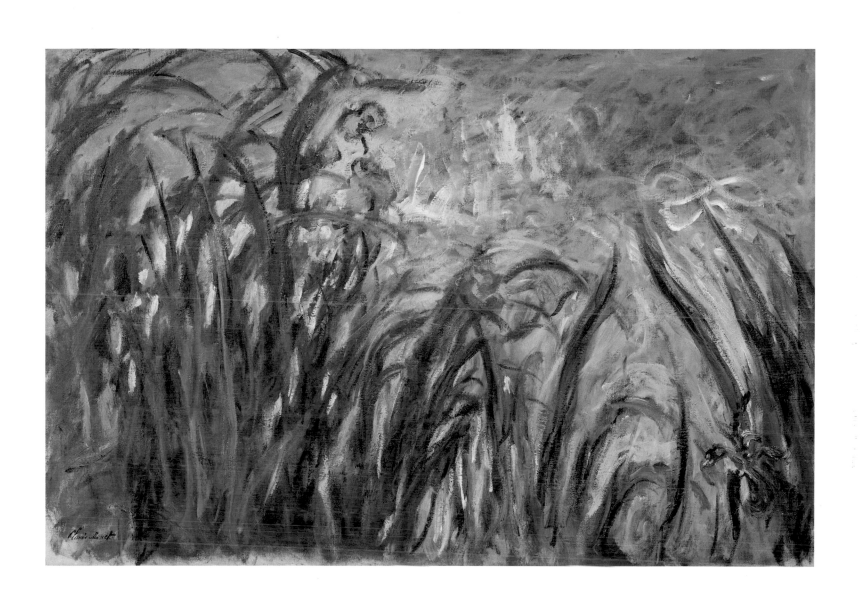

CAT. NO. 20
Yellow and Mauve Irises
(*Iris jaunes et mauves*), 1924–1925
Oil on canvas
41¼ x 61 in. (106 x 155 cm)
Inv. no. 5083

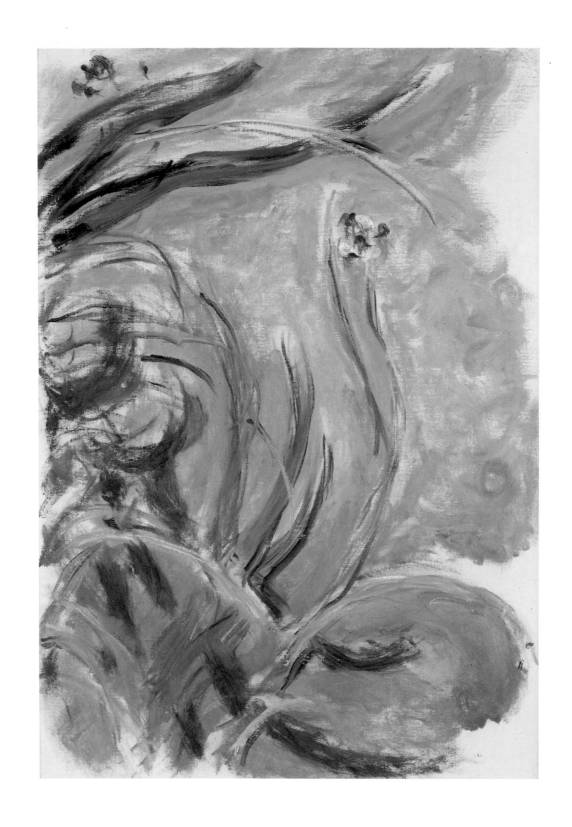

CAT. NO. 21
Iris (Iris), 1924–1925
Oil on canvas
41⅜ x 28¾ in. (105 x 73 cm)
Inv. no. 5076

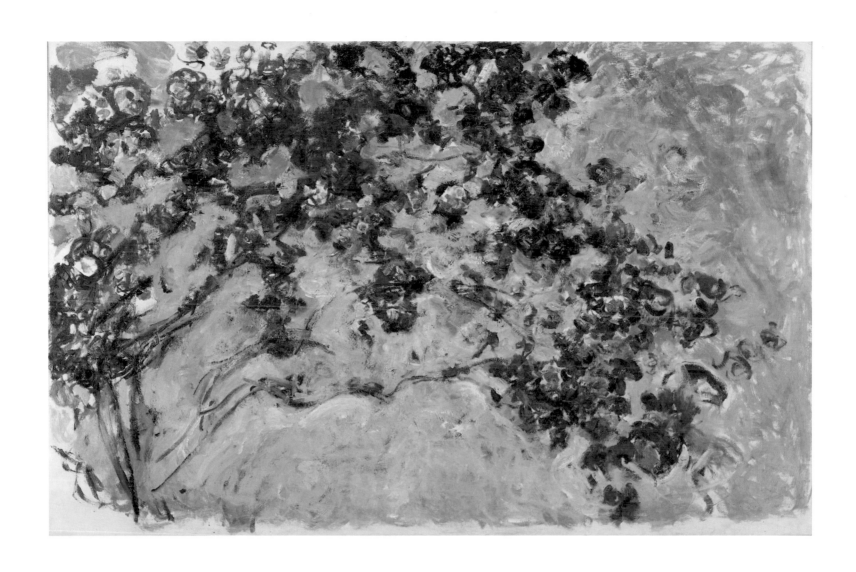

CAT. NO. 22
The Roses (Les Roses), 1925–1926
Oil on canvas
51⅛ x 78¾ in. (130 x 200 cm)
Inv. no. 5096

Selected Bibliography

For an extended bibliography of the artist and the period, including an exhibition history, see Tucker, *Monet in the '90s.*

Gordon, Robert, and Andrew Forge. *Monet.* New York: Harry N. Abrams, 1983.

Hoog, Michel. *The Nymphéas of Claude Monet at the Musée de l'Orangerie.* Paris: Editions de la Réunion des musées nationaux, 1990.

House, John. *Monet: Nature into Art.* New Haven and London: Yale University Press, 1986.

Joyes, Claire. *Claude Monet: Life at Giverny.* New York and Paris: The Vendome Press, 1985.

Joyes, Claire, et al. *Monet at Giverny.* London: Mathews Miller Dunbar, 1975.

Moffett, Charles S., James N. Wood, and Daniel Wildenstein. *Monet's Years at Giverny: Beyond Impressionism.* Exh. cat. New York: The Metropolitan Museum of Art, 1978.

Murray, Elizabeth. *Monet's Passion: Ideas, Inspiration, and Insights from the Painter's Garden.* San Francisco: Pomegranate Artbooks, 1989.

Stuckey, Charles F., ed. *Monet: A Retrospective.* New York: Hugh Lauter Levin Associates, 1985.

—. *Monet Water Lilies.* New York: Park Lane, 1988.

Tucker, Paul Hayes. *Monet at Argenteuil.* New Haven and London: Yale University Press, 1982.

——. *Monet in the '90s: The Series Paintings.* Exh. cat. Boston: Museum of Fine Arts, 1989.

Wildenstein, Daniel. *Claude Monet: Biographie et catalogue raisonné.* 5 vols. Lausanne-Paris: La Bibliothèque des Arts, 1974–1991.

Monet: Late Paintings of Giverny from the Musée Marmottan
was produced by the Publications Department of
The Fine Arts Museums of San Francisco,
Ann Heath Karlstrom, Director of Publications.
Edited by Fronia W. Simpson.

Book design by Robin Weiss Graphic Design, San Francisco.
Type composed on a Macintosh Quadra 800 in Fournier and Runic Condensed.
Printed on Zenith Silk 150gsm by Balding + Mansell, Great Britain.